Edvard Munch

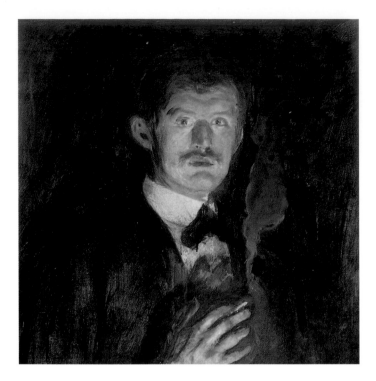

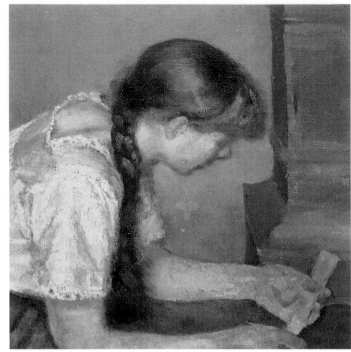

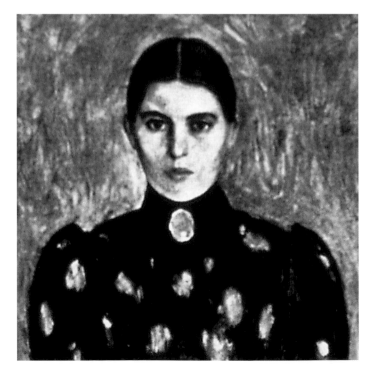

Text: Elisabeth Ingles
© 2005 Sirrocco, London, UK (English version)
© 2005 Confidential Concepts, worldwide, USA
© 2005 Estate Munch / Artists Rights Society, New York, USA /
 BONO, Oslo, Norway

ISBN 1-84013-768-1

Published in 2005 by Grange Books
an imprint of Grange Books Plc
The Grange Kingsnorth Industrial Estate
Hoo, nr Rochester, Kent ME3 9ND
www.Grangebooks.co.uk

Printed in China

Edvard Munch

Love, Jealousy, Death and Sorrow

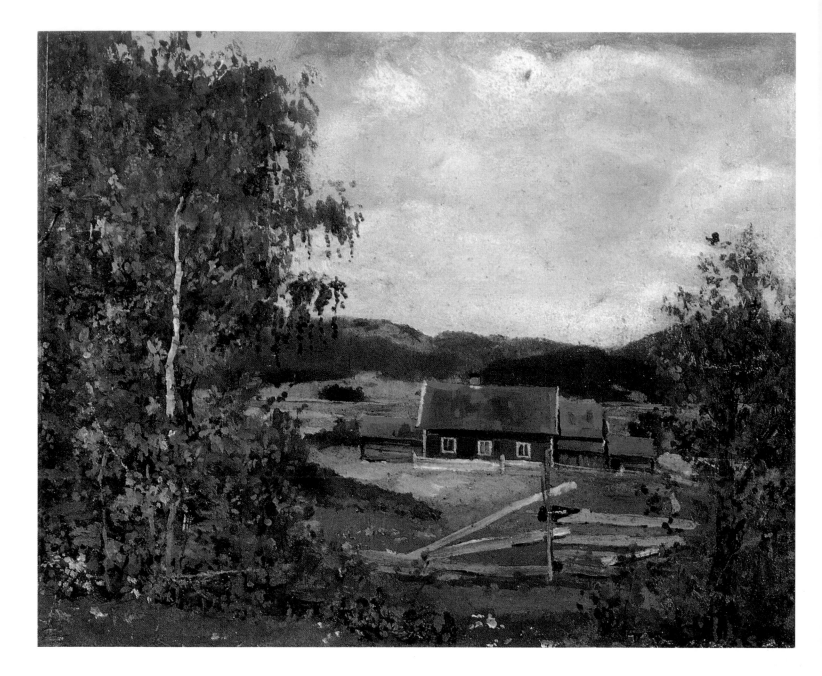

The name of Edvard Munch conjures up, for most people, one irresistibly memorable picture: *The Scream*, a shriek of stomach-churning terror uttered by a cringing figure with a skull-like face outlined against a fiery, blood-red sunset. This iconic image has come to epitomise the angst embodied in the Expressionism of the late nineteenth century. Yet its creator, a gentle soul given to introspection and self-analysis, lived to see his eightieth birthday and witnessed the world-wide critical acceptance of the Expressionist movement which he had been largely instrumental in initiating. Somehow one imagines that the originator of so graphic an image of fear would be too delicate and unworldly to survive the violent upheavals of the early twentieth century, but, although he suffered terribly from depression and anxiety for the greater part of his life, Munch was able to find a mode of living that enabled him to produce a large body of psychologically penetrating, disturbingly beautiful work. He was born in 1863 to a frail young mother, Laura Bjølstad, and her older husband, Christian Munch, a doctor; the following year the family moved to Kristiania, as Oslo was then called. There were five children altogether, of whom Edvard was the second-born and elder son. Early on Munch understood that he had a difficult twofold heritage to contend with: the physical threat of tuberculosis, which carried off first his mother and then his eldest sister, and the faint but distinct possibility of mental instability. Laura Munch died at the age of thirty, shortly after the birth of her fifth child. The effect on the family may be imagined. The father suffered most acutely, the younger children carrying only the haziest memories of their mother into later life. But the consciousness of loss never left them.

His father's religiosity became more pronounced after Laura's death, to the point where the children's anxiety about offending against Christian principles instilled in them a palpable fear of eternal damnation. The unhappiness of his childhood experience of death was compounded by his father's unpredictable behaviour. Munch and his brother and sisters were never quite sure how their father's fanatical piety was going to manifest itself – but they could rely on the fact that they would be made to feel inadequate either as dutiful Christians or as obedient children. At times Dr Munch's playful nature, suppressed almost totally by his sadness at the death of his young wife, would resurface briefly and he would play with his children like any normal father. But then the blackness would reassert itself, and he would lash out violently. Indeed, in later life Munch would write that his father became almost insane for short periods. This must have been quite terrifying for a sensitive, quiet young boy who was himself prone to frequent bouts of illness. The death of his sister Sophie, the eldest child, when Edvard was thirteen, caused him even more profound suffering than had the loss of his mother when he was five. He watched anxiously as his father prayed over the girl, unable to do anything for her. To him, and to Sophie, Dr Munch's promises of eternal heaven meant nothing compared with her burning desire to live.

1. *Landscape, Maridalen, near Oslo*, 1881, Oil on wood, 22 x 27.5 cm, Munch Museum, Oslo.

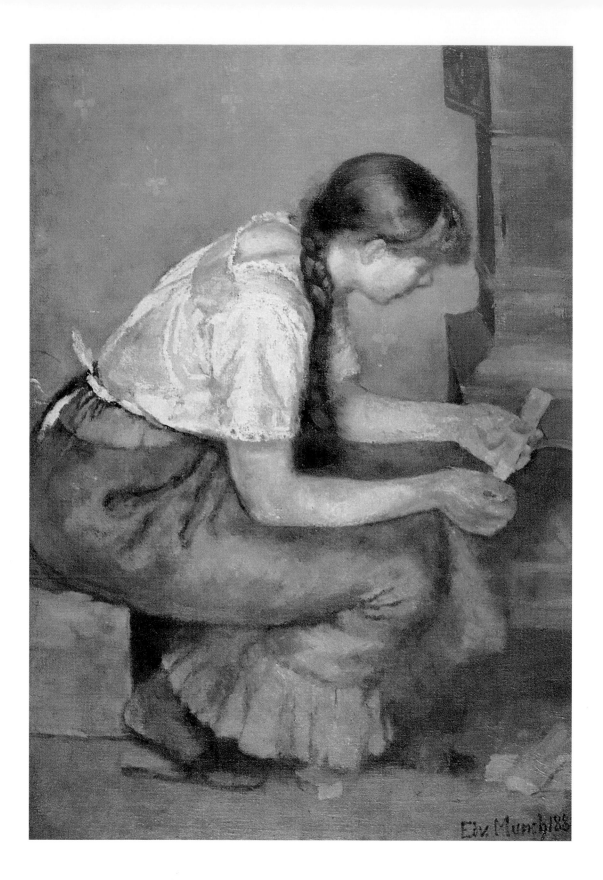

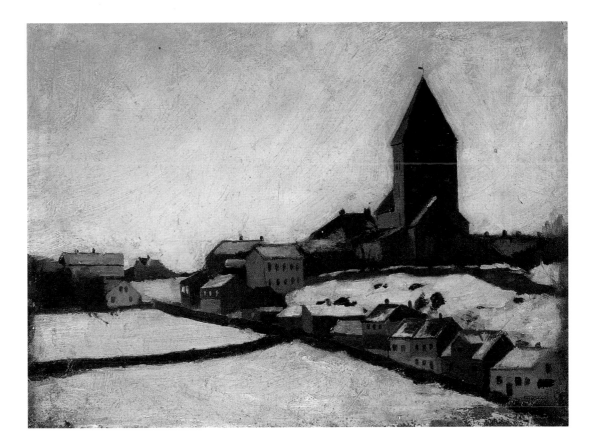

Her struggles were unbearable to watch. Edvard's utter helplessness and sorrow were channelled some years later into a painting that he returned to obsessively: the marvellous *The Sick Child*, the first version of which was executed in 1885-6. (There were to be six versions altogether, created at roughly ten-year intervals.) In this large painting, almost four feet square (120 cm), he struggled throughout his life to express what he felt so intensely about his sister's death. During her last illness she repeatedly pleaded for help, for relief from pain – neither Edvard nor his doctor father was able to provide it. This incapability was transformed into a feeling of guilt that he had survived and she had not. His attempts to put himself in her place in the picture were doomed to failure, just as he had failed to take her place as she lay dying. To the end of his life he was unable to resolve this. His guilt is poured into the picture, which is almost unbearably poignant. The young girl's face is already a ghost, almost disembodied as she silently yearns to go on living. With its deep layers of meaning and evocation of the state of the artist's soul, this can fairly be termed one of the first Expressionist paintings. He himself termed it 'a breakthrough' in his style, and the collector and critic Jens Thiis, later Munch's biographer, called it 'the first monumental figure painting in our Norwegian art'.[1]

2. *Girl lighting a stove*,
 1883, Oil on canvas,
 96.5 x 66 cm,
 Private Collection.

3. *Old Aker Church*,
 1881, Oil on canvas,
 16 x 21 cm,
 Munch Museum, Oslo.

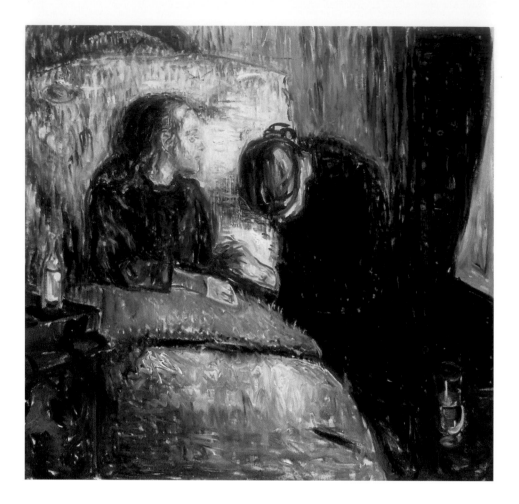

The emphasis on religious piety, which appeared to do not the slightest good, as prayers for the life of mother and sister went unheeded, and the authoritarianism of a father who punished disproportionately for the most minor transgressions, came together in Munch's mind to give him a view of God as unjust, full of anger and entirely without compassion. Although he did not dare to contradict his father by refusing to go to church, by the time he was in his early twenties he had reached the conclusion that God did not exist, and that there was no eternity. This belief in the non-existence of God remained broadly unaltered throughout the rest of his life, though he changed his mind about the possibility of a continued existence in a kind of afterlife. With some bravery, Munch took the decision to become a painter in the face of his father's firm preference that he should study engineering. His father reluctantly acceded, on the advice of a draughtsman friend. One of Munch's earliest self-portraits, from a year or so later (*Self-Portrait*, 1881-2), shows a young man of sensitive, even sickly aspect, his large pale face, full curving lips and sloping shoulders giving little cause to credit him with any kind of physical or mental toughness. Yet there is, in the clear gaze, something of a challenge to the onlooker who might thus dismiss him.

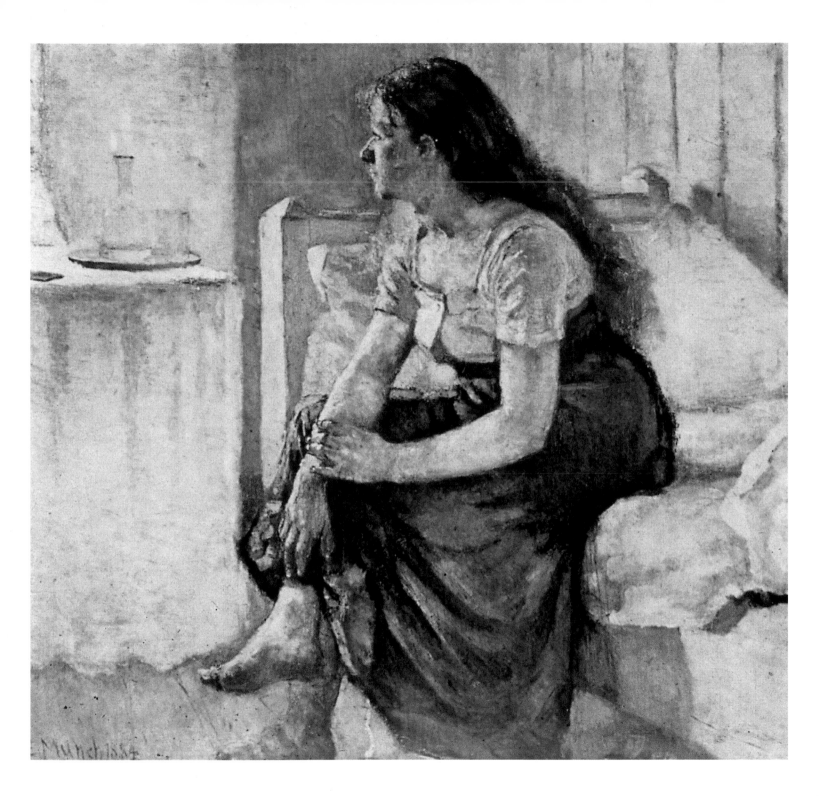

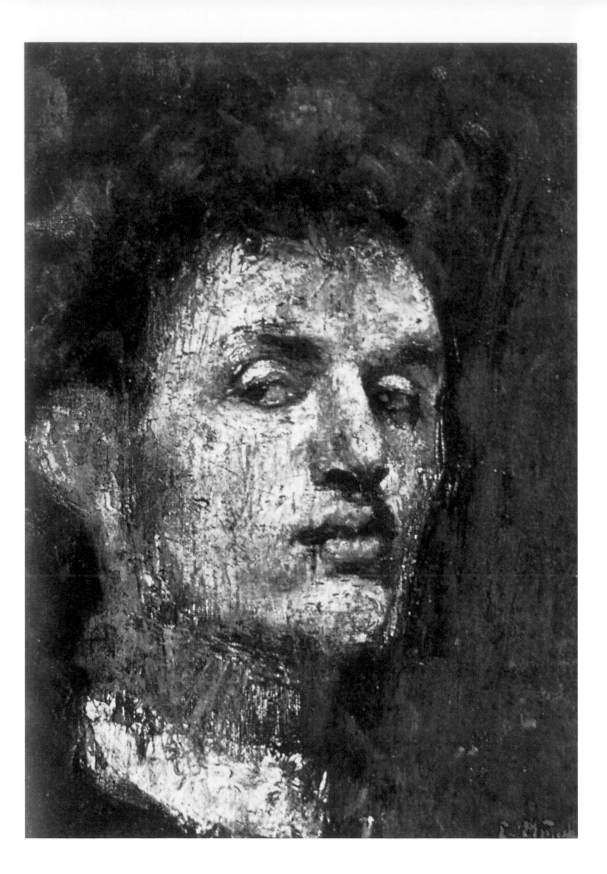

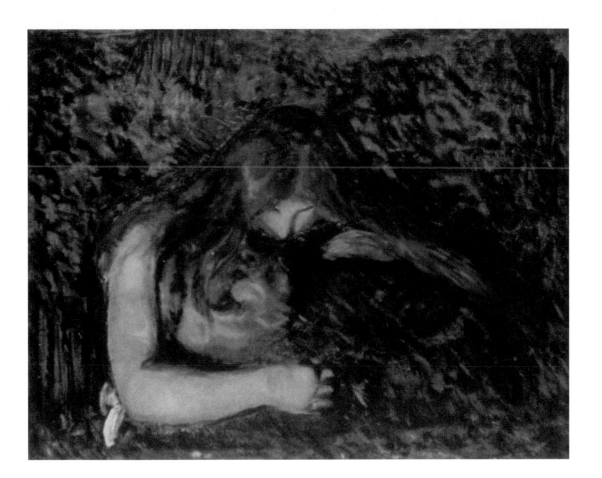

There is character here. After their mother's death, the children were comforted a little by the advent of her younger sister Karen, who came into the family and took over as housekeeper and governess. She had done some dabbling in painting herself, and quickly came to recognise that Edvard had an unusual talent. Her encouragement was greatly valued by him later in his life, although at first he did not appreciate it as much as he might. A portrait of his aunt done in 1884 (*Karen Bjølstad in a Rocking Chair*) goes some way to making amends – the calm young woman is portrayed sitting in the window, gently rocking herself. His portraits of this period are strikingly mature, particularly that of his sister Inger, which reveals a young girl with great strength of character in her sombre, slightly averted gaze (*Inger Munch*, 1884). Norway was an artistic backwater at this time – the few major painters of the period included Christian Krohg, Fritz Thaulow and Erik Werenskiold, who formed the native school, with its keynote of naturalism. They mounted their first Autumn Exhibition in 1882, beginning a regular series that at first attracted much critical disapproval.

6. *Self Portrait*, 1886,
 Oil on Wood,
 33 x 24.5 cm,
 Munch Museum, Oslo.

7. *Vampire*, 1883-1884,
 Oil on canvas,
 91 x 109 cm,
 Munch Museum, Oslo.

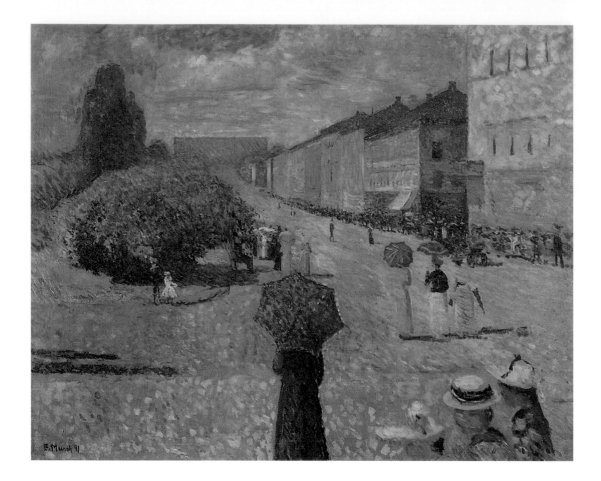

8. *Spring Day on Karl Johan Street*, 1890, Oil on canvas, 80 x 100 cm, Billedgalleri, Bergen.

Manet was their idol, their lode-star. Munch embraced this group warmly, and in the course of some months was taught how to use colour by Krohg. However, he felt he had to go abroad to gain the stimulus and training he needed. In 1885 he was enabled to go to Paris thanks to the generosity of Thaulow, always a supporter, and grants from various bodies. Thaulow – the brother-in-law of Gauguin, as it happens – not only gave him moral and financial support in the face of critical hostility, but also bought one of his earliest successes, *A Servant Girl (Morning)* of 1884.

Before he left for Paris, Munch met the woman who was to cause him perhaps the deepest grief and psychological damage of his emotional life: Emilie (Milly) Thaulow. He was now twenty-two; she was twenty-four, married to his cousin Carl, and with no moral scruples about engaging in an adulterous affair. She was beautiful and blonde in a classic Scandinavian way, and admirers flocked round her. She toyed with Munch, who fell heavily for her. At first they enjoyed a lovers' idyll, but he was unable to retain the interest of this sensual and amoral woman for long. Munch continued to show work at the regular Autumn Exhibitions in Oslo,

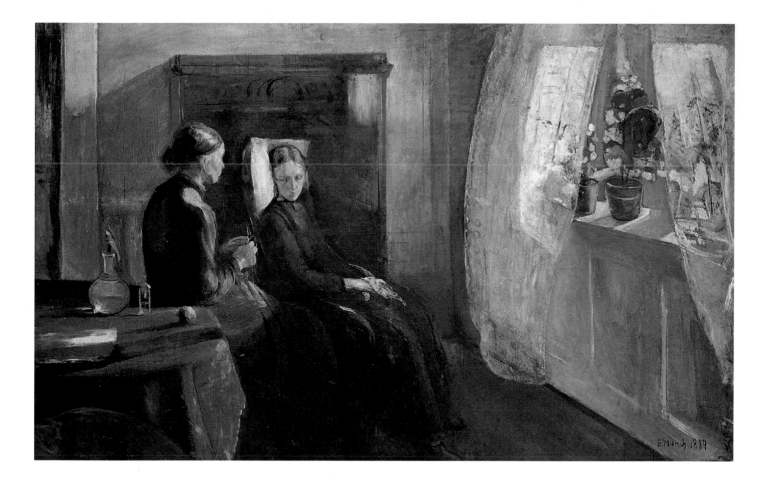

but the critics took not the slightest notice of his offerings at the 1887 show. Feeling neglected and slighted professionally, he was reduced to a state of deep neurosis when he realised that the experienced Milly was not after all faithful to him. His love for her, always slightly unhealthy, now became an obsession, fuelled by the fact that she made it plain she was out of his reach. He kept a precarious hold on his sanity by pouring out his feelings into his semi-fictional diaries, a form of release that he relied on throughout most of his life. In Paris, where his arrival was delayed by a year through a bout of severe illness, he saw the work of the leading painters of the day: the Impressionists, the Post-Impressionists and the Symbolists. There is an unmistakably Manet-like quality to some of the full-length portraits that followed, while the style of Emile Bernard and Puvis de Chavannes is strongly evoked by the colours and shapes of a picture such as *Evening: Inger on the Shore* (1889). Another clear influence is that of the Pointillists: *Spring Day on Karl Johan Street* (1890) could almost have been painted by Pissarro or Signac. This sojourn in the French capital affected his work profoundly and resulted in Krohg's eventual description of him as Norway's first and only Impressionist.

9. *The Spring*, 1889,
 Oil on canvas,
 169 x 263.5 cm,
 Munch Museum, Oslo.

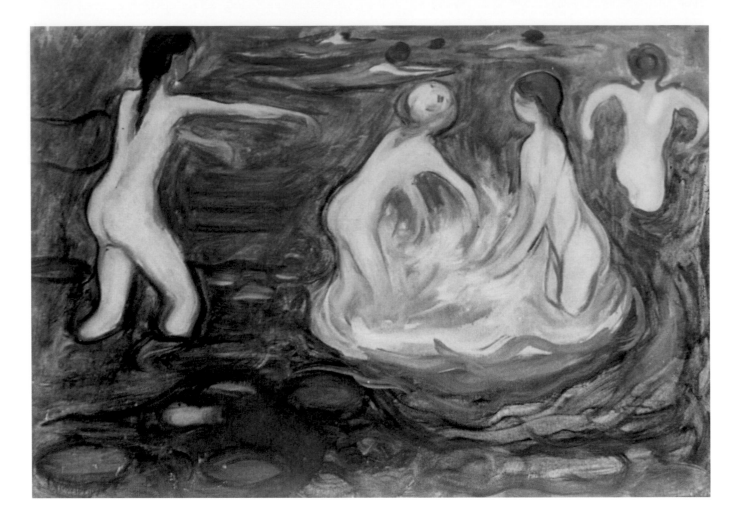

Over this and successive visits to France he imbibed other important influences: he very much admired Van Gogh and Gauguin, and drew stylistic inspiration from Odilon Redon, Pierre Bonnard and Eduard Vuillard, as well as from the flowing forms and brilliant colours of Art Nouveau and the recently discovered Japonaiserie that had partly inspired it. Struggling against the materialism, conservatism and provincialism of late nineteenth-century Kristiania, a group of intellectuals had gathered in about 1886 under the leadership of the writer Hans Jaeger. 'Kristiania's Bohemia' adopted Munch, who embraced the group's values enthusiastically – the movement took its name from Jaeger's book – and was inspired to paint some outstanding works, such as *The Men of Letters* (1887). Jaeger and his fellow bohemians believed in everything Munch's father disliked and distrusted – atheism, free love, alcohol and anarchy. The breakdown in relations between father and son worsened, and indeed never healed. Munch's work was not favourably received by the critics – a reaction wearily familiar to his Impressionist colleagues in France – but he defended himself vigorously and his

10. *Bathing Girls*, 1892,
Oil on canvas,
Munch Museum,
Oslo.

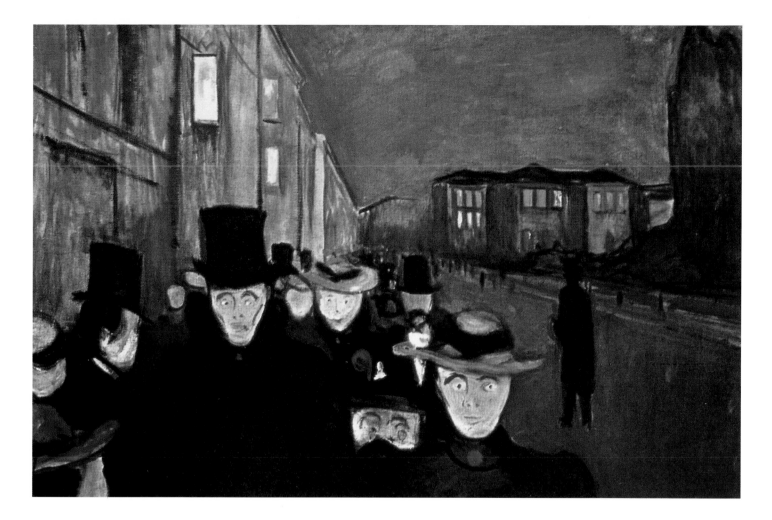

sensitive soul was surprisingly robust in the face of such attacks. It all helped to push him further in the 'bohemian' direction, though his art developed of its own accord under its creator's confidence in its worth. But the *Zeitgeist*, embracing both Impressionism and its antithesis, Symbolism, informed his work and was influential in shaping his ideas. This is exemplified in *Spring Evening on Karl Johan Street* (1892). What a powerful dichotomy we have here! The crowded pavement is full of movement, yet the figures are dressed as if in mourning, and the features of the nearest walkers are almost skull-like – not much sign of spring here. Hostility and incomprehension are apparent on the faces staring at the artist's panic-filled attempts to find Milly, his obsessional love. A clamp-down by the Norwegian government on the free-thinking, free-living ideas of the bohemians, which went so far as to imprison Jaeger for publishing an 'immoral' novel in 1885, led to a rethink among avant-garde painters, who now turned to themes from nature as being rather safer than their previous preoccupations with sex and unbridled emotion.

11. *Spring Evening on Karl Johan Street*, 1892, Oil on canvas, 84.5 x 121 cm, Private Collection, Billedgalleri, Bergen.

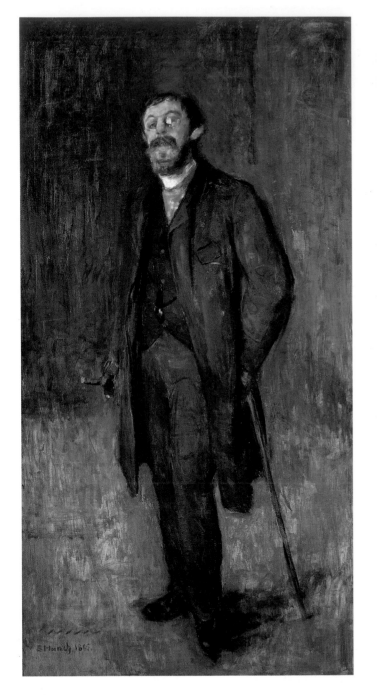

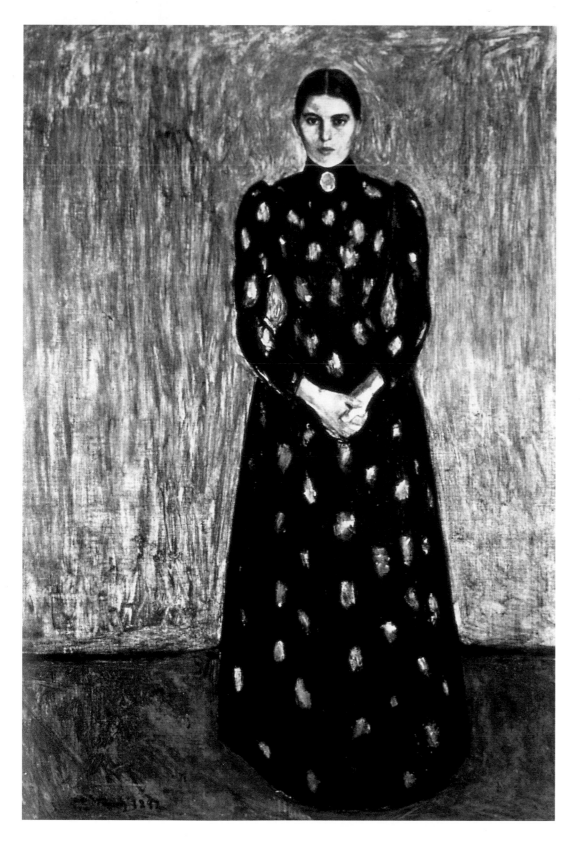

12. *Karl Jensen-Hjell,*
 1885, Oil on canvas,
 190 x 100 cm,
 Private Collection

13. *Dagny Juel
 Przybyszewska,*
 1893, Oil on canvas,
 148.5 x 99.5 cm,
 Munch Museum,
 Oslo.

14. *Portrait of Inger, the
 Artist's Sister,* 1892,
 172 x 122.5 cm,
 Munch Museum,
 Oslo.

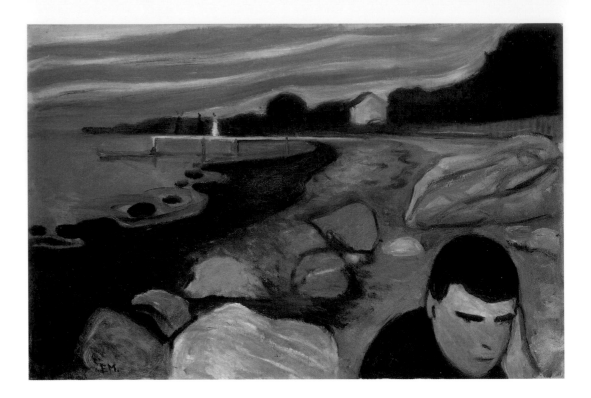

All the intellectuals and artists in Scandinavia suffered to some extent under this atmosphere of stifling bourgeois smugness, which seemed so retrogressive to those who were pushing for the acceptance of new ideas, and new political and social freedoms. Munch succeeded in putting on a one-man show at the University in spring 1889 – the first such exhibition ever to be mounted in Norway. He was never afraid of his own talent, and was not burdened with false modesty. It was quite an achievement for a young man: 110 works in all were shown, with a mixed critical reception. But it paved the way for a state grant, and served notice that here was a young artist to watch. Munch spent the summer of 1889, the first of many, at Åsgårdstrand, on the coast, along with his sister Inger and friends Christian Krohg and his wife Oda, Gunnar Heiberg, Hans Heyerdahl and others.

He loved this simple life, and returned to it whenever he could. Various relationships developed or unravelled there – that year his sister found herself on the brink of marriage, which came to naught, while his friends Christian and Oda Krohg were mending their commitment to each other following the three-way love affair involving Jaeger, terminated the previous year amid the drama of a suicide pact which failed in an almost risible fashion. The birth of a baby to the Krohgs seemed to bring calm to their ménage, but it was not to be for long, since Oda would become involved a couple of years later with a young man, Jappe Nilssen; the jealousies thus aroused became the subject of several of Munch's finest works. (It is Jappe whose features recur in the *Yellow Boat* pictures, such as *Melancholy*.) The free love ethic which Jaeger had advocated so vehemently threatened the equilibrium of everyone in the

15. *Melancholy*, 1892,
Oil on canvas,
64 x 96 cm,
Munch Museum, Oslo.

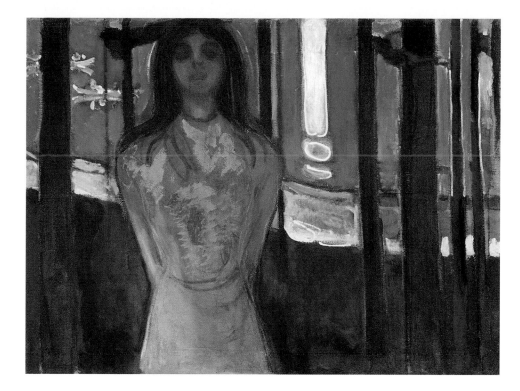

circle, because none of them was able to rise above the corrosive feelings that such 'freedom' gave rise to. Munch, whose relations with women were never to prove satisfactory, fell gently in love too that summer. His love was never declared – possibly because he was still suffering from his catastrophic entanglement with Milly, which always seemed to trump any other emotional involvement. The girl in question was a young painter called Aase Carlsen, and we do not know if she returned his feelings – probably not, since she married that year. Munch remained close to her and her husband, Harald Nørregård, and some years later produced a fine double portrait, a loving interpretation of their happy marriage (*Portrait of Harald and Aase Nørregård*, 1899). He came to rely on Aase as one of the few women who would not threaten him or disturb his peace of mind, and at her death in 1908 he wrote sorrowfully to Harald that he had lost his best female friend.

In Paris in late 1889, Munch received a letter from his aunt Karen telling him that his father had died suddenly. This news precipitated a psychological crisis: because he had comprehensively rejected Christianity and the idea of an all-protecting God, he felt that his father had been simply blotted out of existence, that there was no possibility of an after-life. He knew he had been a little unfair in his judgement of his father's actions and behaviour when the children were young, and the terrible feeling of guilt and loneliness was very hard for him to express – the only way he could visualise his father's end was to picture him walking endlessly down a bleak and empty road (*Allegory of Death – the Barren Road*, 1889-90). For a time he was unable to work.

16. *The voice*, c. 1893,
Oil on canvas,
90 x 118.5 cm,
Munch Museum, Oslo.

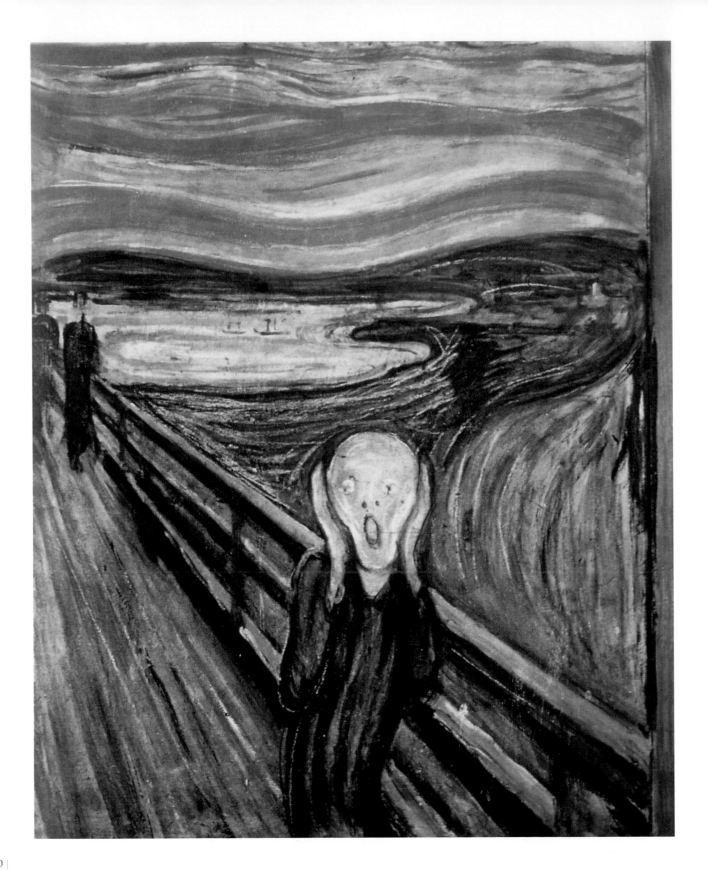

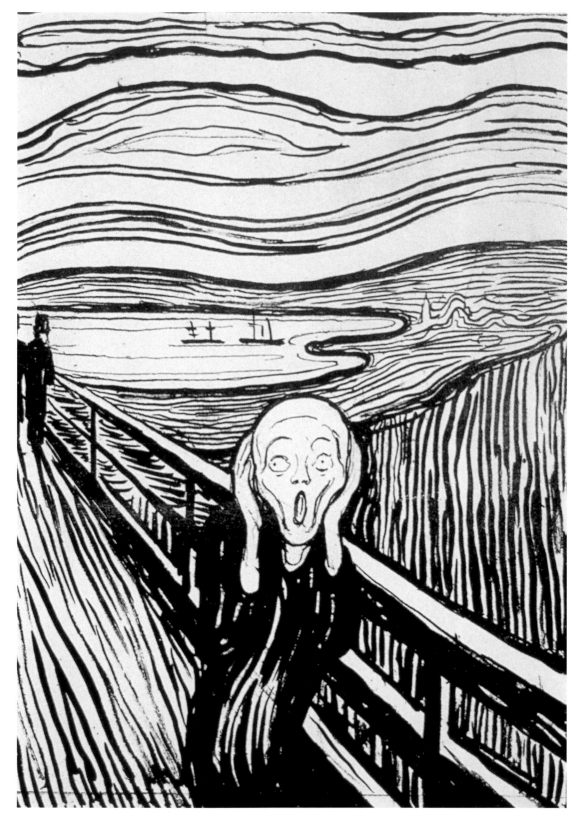

17. *The Scream,* 1893,
 Tempera and pastel
 on board,
 91 x 73.5 cm,
 Stolen from the
 Munch Museum, Oslo
 on 22nd August 2004.

18. *The Scream*, 1895,
 Lithograph,
 35.5 x 25.4 cm,
 Private Collection.

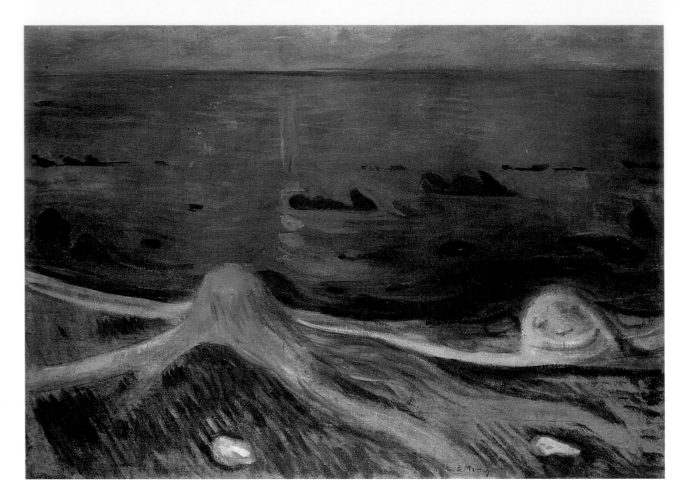

19. *The Mystery of a
Summer Night*, 1892,
Oil on canvas,
86.5 x 124.5 cm,
Private Collection.

A consolation at this time was his close friendship with the young Danish poet Emanuel Goldstein. Goldstein too had undergone a tumultuous love affair, and the shared experience of unrequited love meant that they recognised each other as kindred spirits. Both saw women as vampires, feasting on the lifeblood of the men who loved them. So intense was this relationship that one might even guess at a homosexual element, never expressed or admitted. Munch's semi-fictional 'diary' was very important to him, and he kept it assiduously, seeing in it the basis of a novel about his life. But there is no hint that this friendship was sexual in any way. Gradually he pulled out of the pit of despair, and even began to accept the possibility of everlasting life – but as part of the cycle of nature rather than in a Christian heaven. He embraced Symbolism, finding himself very much in tune with its aims and ideals, and indeed adopted the word to describe his own work, defining it in his notes as 'Nature... transformed according to one's subjective disposition',[2] or what Reinhold Heller calls 'the transforming activity of the artist's mind, mood or emotions'.[3] As a direct result of his 1889 exhibition in Kristiania, partly because of the reigning fashion for all things Nordic in Berlin, above all

literature and art, Munch was invited to show his work at the Association of Berlin Artists in 1892. The head of the Association was closely connected with the Imperial court, so there was hope that he might find influential patrons. However, the section showing his group of paintings did not survive critical disapproval for more than a week. The members of the Association's committee who did not know Munch's work were appalled at the frankness of some of the subjects. A huge fuss blew up, with political repercussions which reached even the Imperial court, and the affair was splashed all over the newspapers. The rest of the group of Norwegian painters withdrew their work, too, after it was felt that they were being belittled. The resulting row led ultimately (in 1899) to the secession of the younger, more avant-garde Berlin painters, in a movement that mirrored the earlier secessions in Munich (1892) and Vienna (1897). Munch, who as a result of the scandal had become more famous than perhaps he wished to be, had many supporters among the younger group, who soon found themselves in alliance with the writers that were making an impact in the city: among them was Strindberg, who had moved there from Sweden.

20. *Moonlight on the coast*, 1892, Oil on canvas, 62.5 x 96 cm, Private Collection, Bergen.

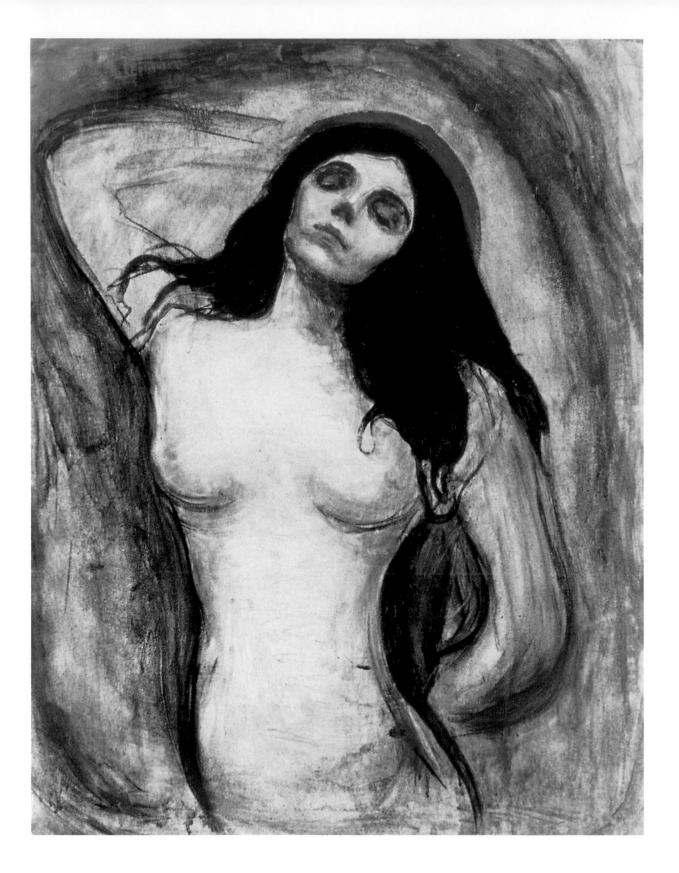

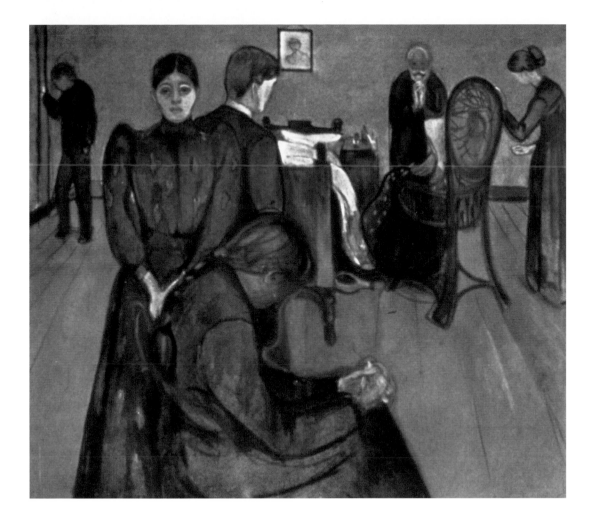

The critic Julius Meyer-Graefe was another Munch champion. For some time Munch had been contemplating the idea of collecting some of his paintings together in a series, called variously *Love* or *The Frieze of Life*. The aim was to paint 'living people who breathe, feel, suffer and love'.[4] The whole series was never exactly clear-cut, and the pictures that he included in it varied to some extent from year to year and exhibition to exhibition, but there are certain major masterpieces that are considered a definite core. Some pictures that had been painted before he conceived the idea of the series were later found eminently apt for inclusion in it. There were various attempts to exhibit the series as a whole at different stages of the artist's career, but they did not always come off. Only after his death were the paintings actually drawn together in one exhibition space, the Munch Museum in Oslo. It is, one supposes, not surprising that he kept revising the contents of the series – the way Munch worked was to return to the same subject several times, in various media, and he might well have thought that one or other of his earlier works on a theme had failed quite to express what he wanted it to say.

21. *Madonna*, 1894,
 Oil on canvas,
 90.5 x 70.5 cm,
 Munch Museum,
 Oslo.

22. *Death in the sickroom*, c. 1893,
 Tempera and pastel on canvas,
 152.5 x 169.5 cm,
 Munch Museum,
 Oslo.

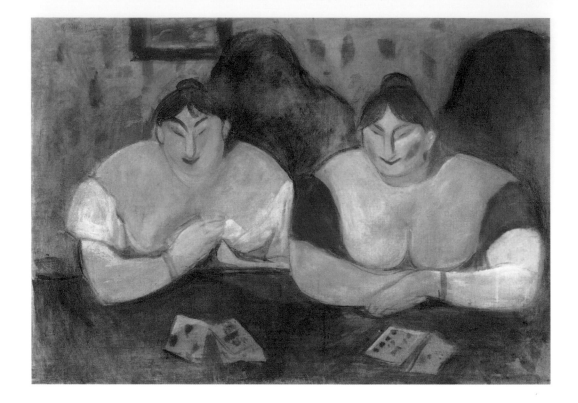

In his somewhat shifting perceptions of male female interaction he now came to see the sexual impulse as holy, and loving sexual intercourse as a sacred act ensuring posterity. The group of outstanding pictures on the theme of sexual love and longing sums up his feelings about women: he longs for love, trusts in the holiness of the act of love to impregnate and continue the species, but is then wracked with jealousy and distrust, finally succumbing to despair. The *Frieze of Life* series runs the gamut from *Man and Woman*, *The Kiss* and *Madonna* to *The Vampire*, *The Yellow Boat* (*Jealousy*) and *The Scream*. *The Kiss* was one of Munch's most constantly revisited and reworked themes. The forms of the man and woman merge into one being, an expression of sexual ecstasy subsuming the individuals and leading to their extinction. In this Munch is perhaps giving form to Wagner's concept of Love-Death, the *Liebestod* that shines darkly throughout his ground-breaking opera *Tristan and Isolde*. In an etching and aquatint of the subject done in 1895, the man and woman are naked. The theme is developed with several *Young Woman and Death* pictures, in which a girl is closely embraced by a skeleton. The painting of the *Madonna* explicitly depicts the point at which the woman experiences a sexual climax, and her partner, from whose viewpoint we look down on her, sees the 'holy moment' when she is impregnated and becomes the universal mother. This beautiful work, with its unearthly greenish flesh and bright halo, was reworked as a drypoint and as a hand-coloured lithograph a few years later, with foetuses or sperm decorating the borders.

23. *Rose and Amélie*,
 1893, Oil on canvas,
 78 x 109 cm, Munch
 Museum, Oslo.

24. *Eye in eye*, 1894,
 Oil on canvas,
 136 x 110 cm, Munch
 Museum, Oslo.

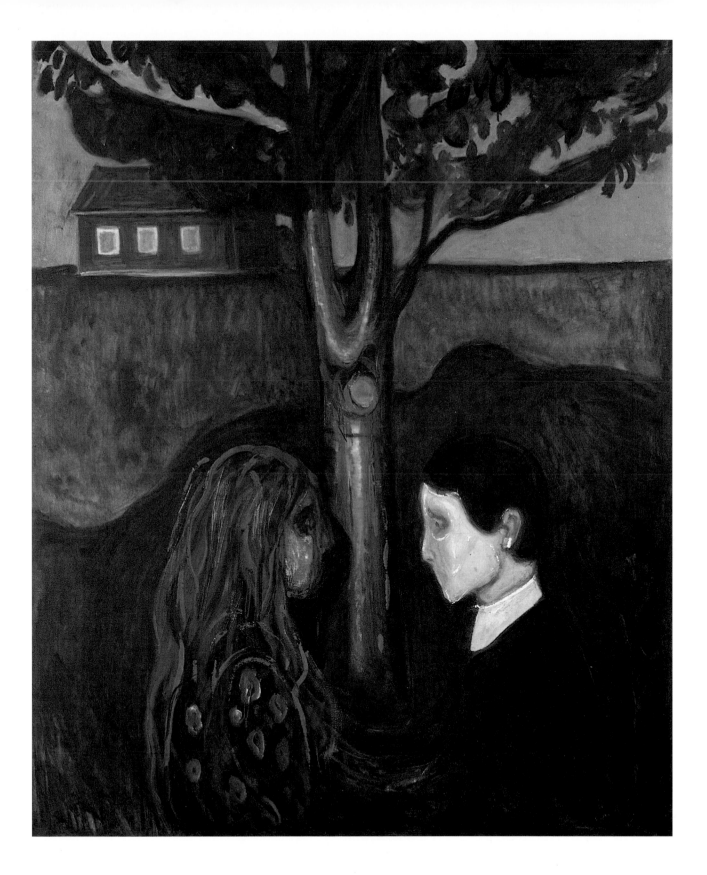

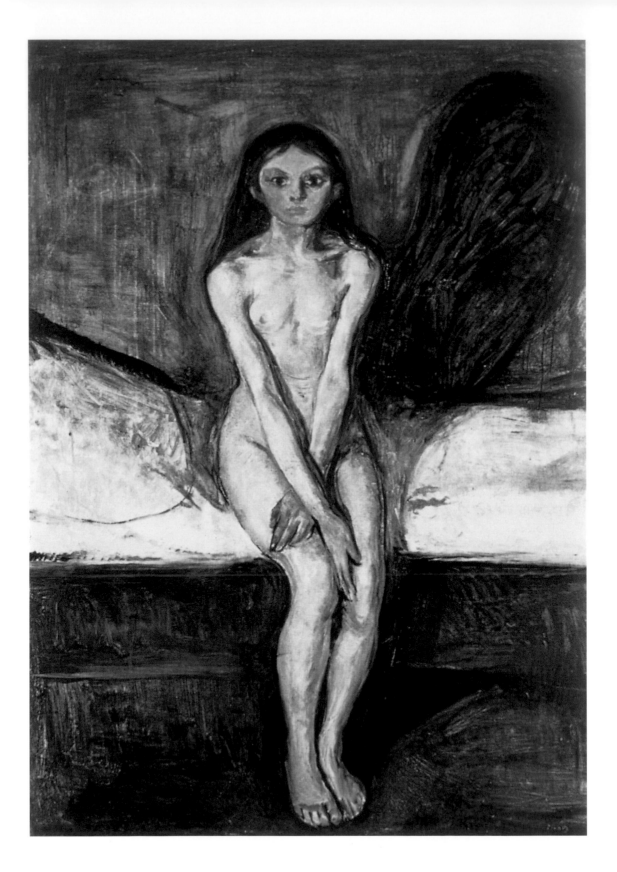

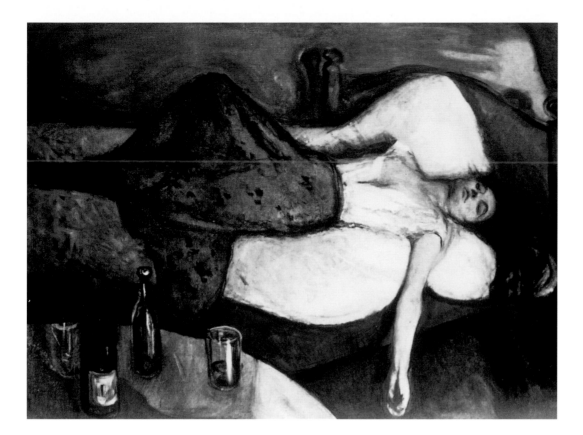

The *Vampire* too recurs many times in Munch's oeuvre. What began as an image of a woman tenderly planting a kiss on her lover's neck was gradually transformed into a vision of the woman as evil, bloodsucking, life-destroying. Much of his unhappiness at the hands of Milly Thaulow and, later, Tulla Larsen found its way into these paintings and drawings, such as *The Beast* (1902). *Jealousy* was another stage in the war between the sexes; it showed Dagny's lover, Jappe Nilssen. *Despair* was renamed *The Scream*, giving voice to the artist's feelings on the subject of love and sex: 'I looked at the flaming clouds that hung like blood and a sword over the blue-black fjord and city... I stood there, trembling with fright. And I felt a loud, unending scream piercing nature.'[5] His retrospective, censored in Berlin, was shown in various major European cities which were less hide-bound and readier to accept his aesthetic, and it fuelled a new respect for his genius. He soon found himself starting to make modest sales to collectors in Munich, where the seceding Norwegian painters had sent their work, and Dresden, and was able to send money home to support his brother and sisters. An anthology of critical writings on his work was published in 1894, with essays by Przybyszewski, Servaes, Meyer-Graefe and Pastor. All this did much to raise his spirits and encouraged him to work harder. Munch felt very much at home in Berlin, in spite of his unfortunate initial reception.

25. *Puberty*, 1894,
 Oil on canvas,
 151.5 x 110 cm,
 Munch Museum, Oslo.

26. *The Day after*,
 1894-1895,
 Oil on canvas,
 115 x 152 cm,
 Munch Museum, Oslo.

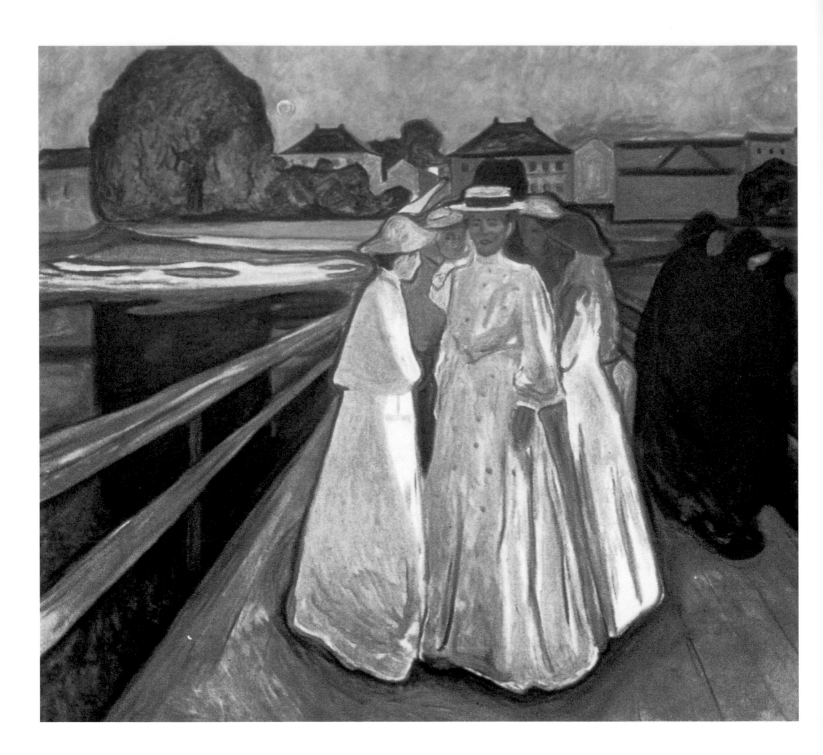

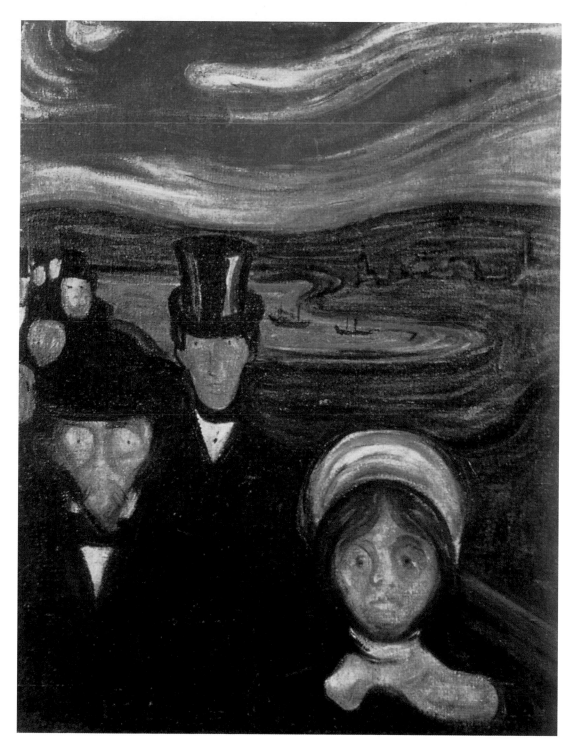

27. *On the Bridge*, 1903,
 Oil on canvas,
 Museum of Modern
 Art, Stockholm.

28. *Anxiety,* 1894,
 Oil on canvas,
 94 x 73 cm, Munch
 Museum, Oslo.

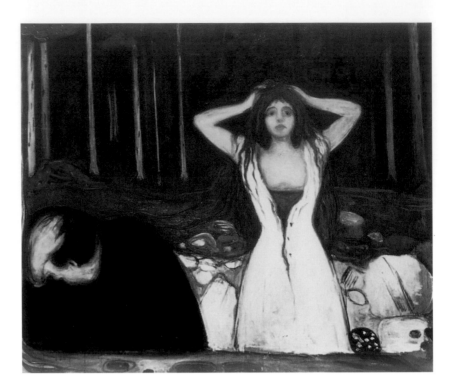

He had a great admiration for German cultural heroes such as Wagner and Nietzsche, and was particularly drawn to the work of Arnold Böcklin, painter of *The Isle of the Dead*. He soon found himself part of another bohemian circle who admired his work and understood what he was trying to do. His friends included, besides Meyer-Graefe and Strindberg, the poet Richard Dehmel, the novelist Stanislaw Przybyszewski, and a number of Scandinavian artists who had collected in the heady, free atmosphere of turn-of-the-century Berlin. The writer and critic Jens Thiis was among them. The poor artist in the garret, Munch produced some of his most memorable works here, among them *Puberty* (1895), which caused another scandal with its frank perception of a shy young girl's awakening sexuality. He also produced a marvellous portrait of his sister in a patterned dress, her hieratic stillness and steady gaze hinting at much emotion under the calm (*Portrait of Inger Munch in a Spotted Dress*, 1892).

An astonishing attack by a right-wing critic in Norway at this point railed against Munch's 'degeneracy' and protested against his receipt of state funds. The intemperate language used would not be out of place among the Nazis and their campaign against 'Degenerate Art' in the 1930s. But the artist's friends continued to support him and his celebration of the irrational and symbolist, which was perceived as a threat to bourgeois rationality and materialism. The group of Berlin bohemian friends often met to drink at a tavern called the Black Pig, and it was from these meetings that the idea for the Secession developed. Munch's close friend Przybyszewski was married to a Norwegian girl, Dagny Juell, known as Ducha, whose seductive slenderness and somewhat feverish

29. *Ashes*, 1894,
Oil and tempera
on canvas,
120.5 x 141 cm,
Munch Museum, Oslo.

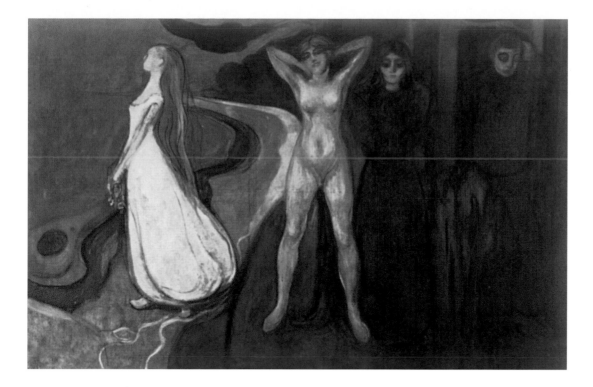

animal magnetism had a powerful effect on Munch, as on most of the men she knew (*Portrait of Dagny Juell*, 1893). Her entry into the group caused it to fragment after a while: jealousy reared its head yet again, and the intellectually pleasing interchange of ideas was threatened with the demon of sexuality. Like most of their circle, both she and Munch had a seemingly limitless capacity for absinthe, the 'Green Fairy', whose poisonous effects apparently did neither of them much harm at the time. There is something of her, as of Milly, in the *Madonna* pictures. Dagny was to come to a premature and dramatic end when she was shot in 1901 in the Georgian capital of Tiflis (Tbilisi) by a deranged young Russian lover, who believed he was fulfilling her husband's wishes.

His belief in the recycling of all matter, a constant circulation of the life force from a corpse to a plant or tree that feeds new human life in a kind of eternity, lay behind the many paintings on the theme of death that Munch produced for his next exhibition, for the Berlin Secessionists, in 1893. Among these is *The Dead Mother*, which expresses the idea that the body decomposes and its substance is returned to nature to nourish future generations, plants or soil. He even went so far as to sketch a corpse with the gases of decomposition issuing from it. Death was of course a preoccupation of Böcklin, the German painter he most admired. A masterpiece of this period is *Death in the Sick-Room* (1893–4), which is a group portrait of his entire family: he and his two sisters in the foreground, his brother, father and aunt at the back. The figure who is dying presumably refers to the eldest child, Sophie, but these people are shown as they were in 1893, not as they looked at the time of Sophie's death sixteen years earlier.

30. *Woman in Three Stages*, 1894, Oil on canvas, 164 x 250 cm, Private Collection, Bergen.

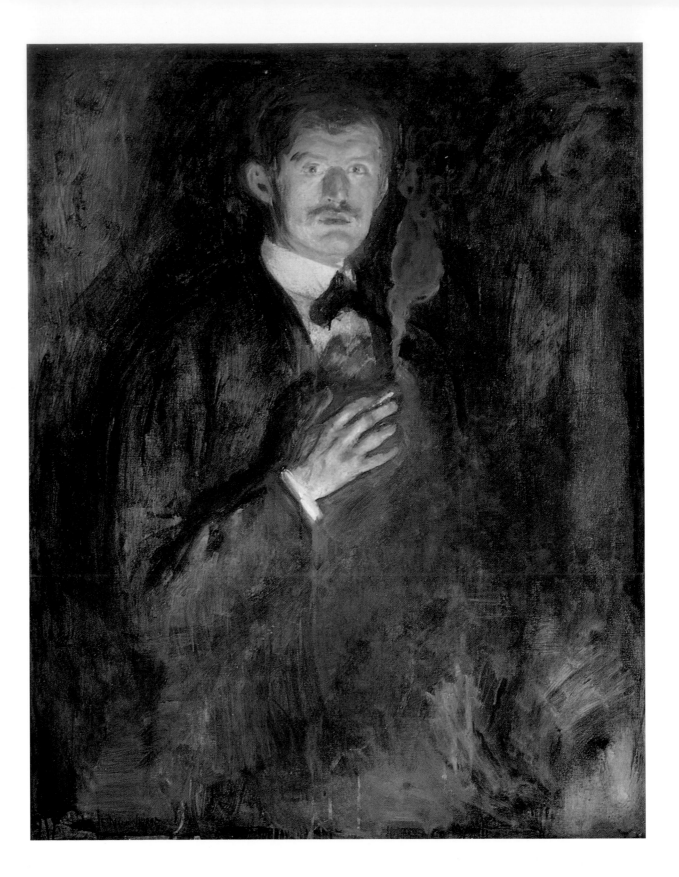

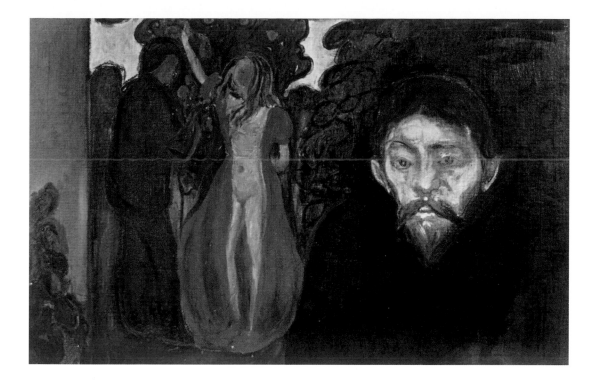

Dr Munch, it should be remembered, was dead by this time, but the artist shows him as he would have been. The painting, which was executed in casein, a medium new to Munch, was warmly received and was the true beginning of his acceptance as an artist worth taking seriously. He began a period of strenuous activity during which he painted *Separation* (1894), a graphic depiction of the moment when a woman tells her lover that she no longer wants him. He lived fairly happily in Berlin, seeing a great deal of Przybyszewski and Dagny (*Portrait of Stanislaw Przybyszewski*, c.1893) and creating numerous outstanding paintings and graphic works. But his supply of funds was drying up, and only the kindness of a German patron kept him going. He was also frequently ill. The *Self-Portrait with Cigarette* of 1895 clearly delineates the bohemian excesses of this period. The smoke from his cigarette drifts up past a pale, staring face which looms at us out of the shadows. The unfinished quality only adds to the drama. He was by this time thirty-two years old. He felt a strong desire to add to his great *Love* or *Frieze of Life* series, creating a kind of narrative for the paintings in his 'diaries'. He also decided to arrange his 'Death' paintings in a sequence. The triple aspect of woman appears in *Symbolic Study*, a gouache of 1893: framing the central portion are the innocent girl, her flesh yellowish in tone, the woman in the full flush of motherhood and fecundity, coloured green, and, lying across the top, woman in her sexual aspect, coloured purplish-red; in the centre are three female heads oppressing a man, who is resting on the dead body of another woman below.

31. *Self Portrait with Burning Cigarette*, 1895, Oil on canvas, 110.5 x 85.5 cm, Munch Museum, Oslo.

32. *Jealousy*, 1894-1895, Oil on canvas, 67 x 100 cm, Private Collection, Bergen.

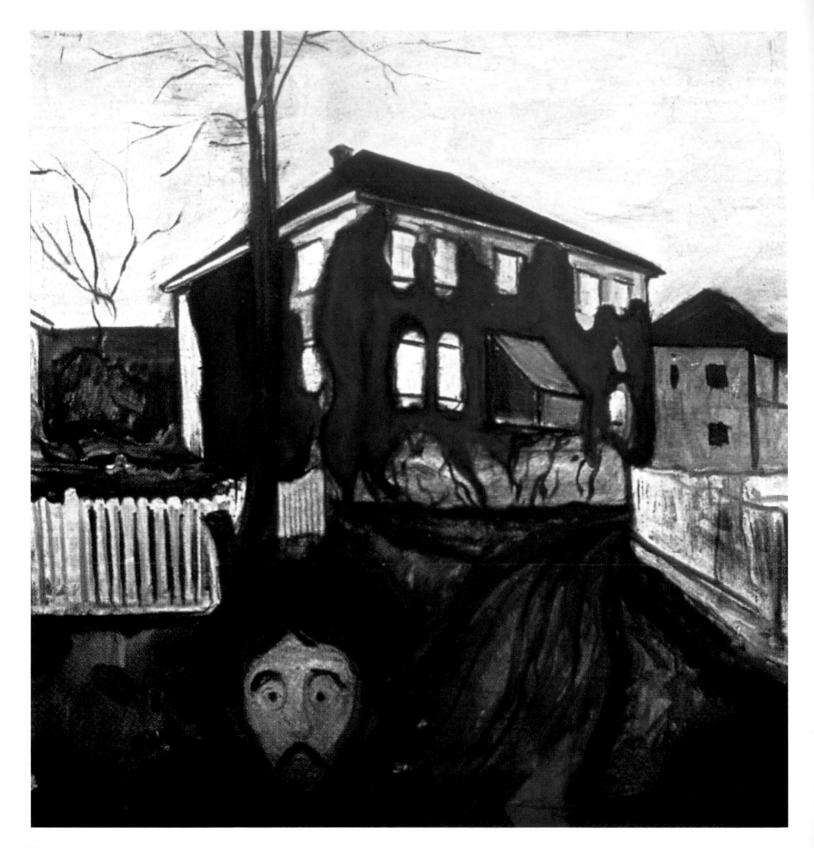

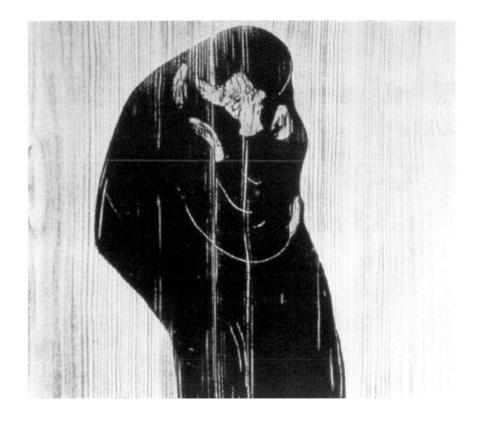

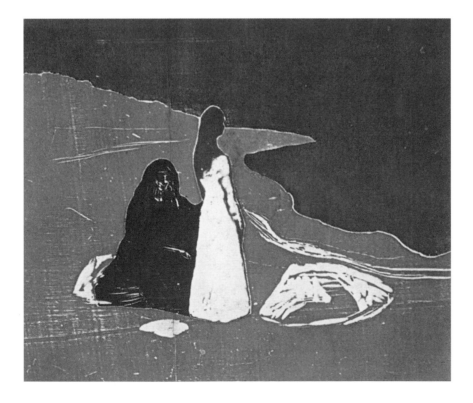

33. *Red Virginia Creeper*,
 1898-1900,
 Oil on canvas,
 119.5 x 121 cm,
 Munch Museum,
 Oslo.

34. *The Kiss*, 1898,
 Woodcut, 41 x 46 cm,
 Munch Museum,
 Oslo.

35. *Two Women on
 the Shore*, 1898,
 Woodcut,
 45.5 x 51 cm,
 Clarence Buckingham
 Collection.

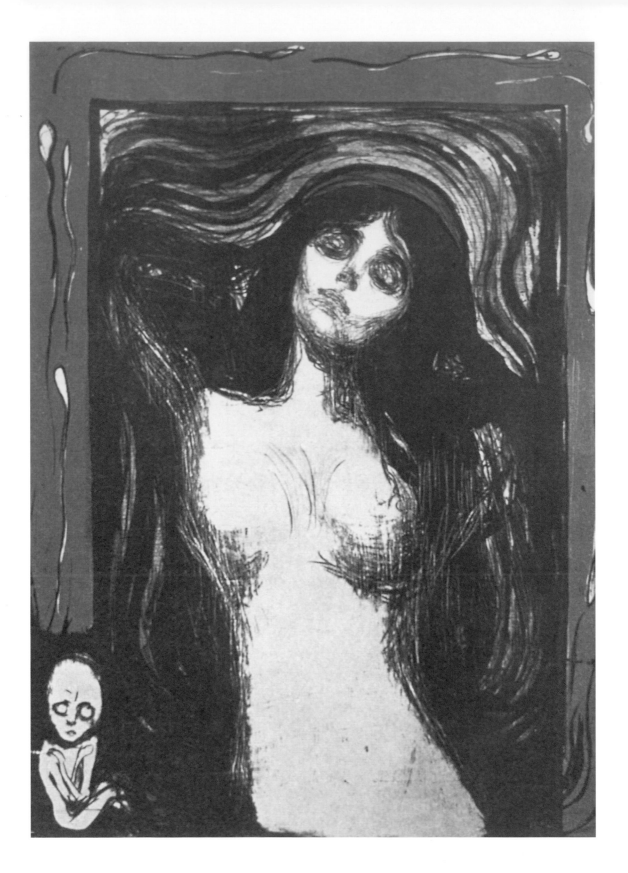

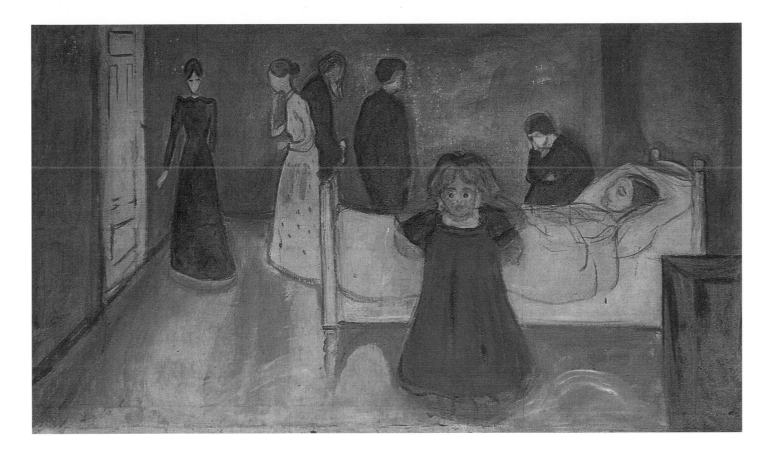

This painting sums up all that Munch was trying to say about love and life in his series. The combination of several themes into one picture was something that he was to revert to frequently over the next few years.

Munch was not only a painter; in the course of his life he mastered every aspect of graphic art, beginning in Berlin when he was thirty-one. The initial impetus to learn print-making was the pressing need to earn money. His German patron, Baron von Bodenhausen, suggested to him that this was the way forward, both in terms of earnings and of expanding his basis for collectors. He started with engraving and moved on to lithographs; but, in the beginning at least, his hope of success was not fulfilled, in spite of being fortunate enough to secure the patronage of Count Kessler, an influential collector. His colour lithographs are particularly successful, their blocks of pure colour bringing a new, sharper expression to the emotions explored in the paintings on which they were based. His woodcuts, too, a form that he first encountered in Paris, were marvellously succinct expressions of an emotional moment – nothing could be more redolent of its eponymous emotion than *Melancholy* of 1896. The extraordinary *On Man's Mind* of 1898 uses the simplest of woodcut techniques to produce a compelling, sinuous pattern expressing the oppression of man by woman.

36. *Madonna*, 1895-1902, Colored Lithograph, Stolen from the Munch Museum, Oslo on 22nd August 2004.

37. *The Dead Mother*, 1897-1899, Oil on canvas, 104.5 x 179.5 cm, Munch Museum, Oslo.

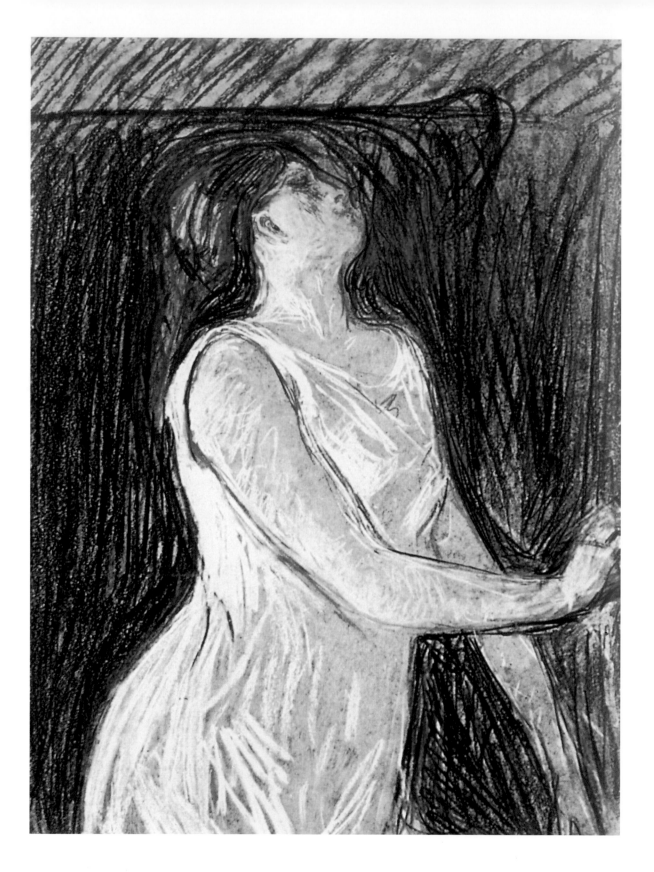

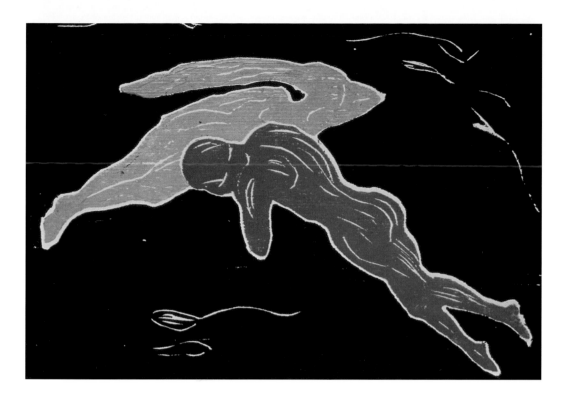

Although he was very attractive to women, Munch's relationships with them were never satisfactory. Let us remember, first, that the death of his mother when he was at so tender an age was a kind of rejection – if he loved a woman he felt she would go away from him, leaving him despairing and longing; secondly, that he was a product of his time, experiencing the distrust of women that was triggered by the growth of female emancipation, the fear of powerful women that frequently turned to hatred. His affairs with Milly Thaulow and later with Tulla Larsen probably bear some responsibility for this. Many of his generation exhibited this fear and distrust: Strindberg, in particular, who wrote that women's nature was 'crooked and warped and inclined to evil' (his misogyny fuelled by his tortured feelings for Dagny); the dramatist Frank Wedekind (creator of the anti-heroine Lulu); that ambivalent celebrant of loucheness, the poet Charles Baudelaire; and the Belgian painter Félicien Rops with his savage depictions of the feminine principle. But at the same time Munch was able to recognise that women were perfectly capable of love and self-sacrifice. His ambiguous attitude is summed up in another version of womankind's threefold nature, *The Three Stages of Woman* (1894): the virgin, the whore and the crone are here present, though in more subtle guise than these archetypes. The three stages reappear, with the whore transmogrified into the mother, in *The Dance of Life* (1900). Returning to Norway in 1895, he experienced the by now customary unfavourable reaction to his latest exhibition – he was even labelled as bearing the curse of hereditary insanity, a viewpoint with which he might have concurred.

38. *Sketch of the Model Posing*, 1893, Pastel on cardboard, 76.52 x 53.02 cm, Guggenheim Museum, New York.

39. *Encounter in Space*, 1899, Colored lithograph, 18 x 25 cm, Private Collection.

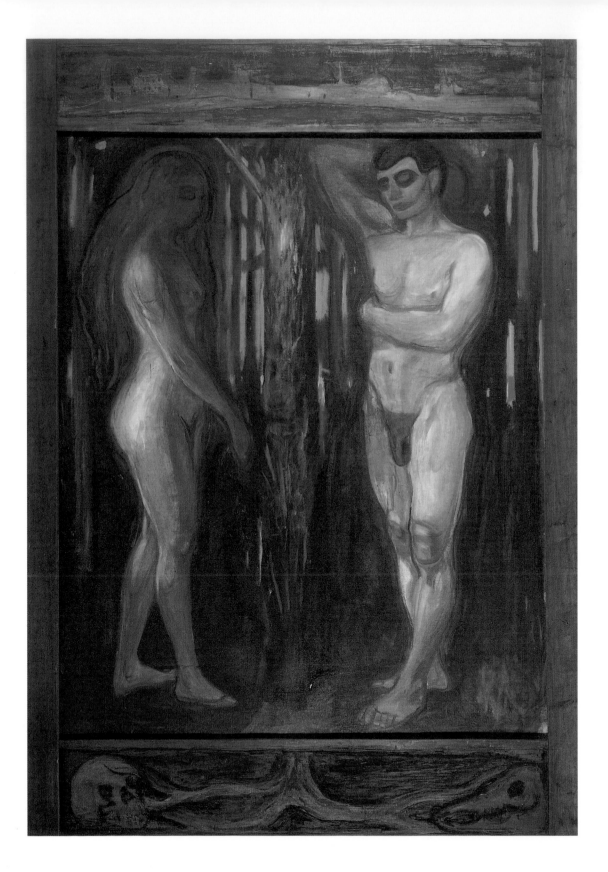

Unable to cope with the strictures of his own countrymen, and sorrowing at the death of his brother Andreas, he moved on to Paris. There ten pictures in the *Frieze of Life* series were shown at the Salon des Indépendants and at Samuel Bing's Art Nouveau gallery. Most summers he returned to his little house in Norway, at Åsgårdstrand, which he loved. From 1892 until 1908 he spent a great deal of time in Germany, practically adopting it as his country. The Berlin Secessionists' more conventional members were suspicious of him, and he did not have another exhibition with the group until 1902 – which, however, was a success, gaining him the esteem of the influential dealer Paul Cassirer. It was gained at some cost. His relationship with the beautiful and determined Tulla Larsen commenced in 1898; she was to cause him, in her own way, even more trouble and nervous exhaustion than had Milly Thaulow earlier. Tulla was single-minded in her pursuit of the artist. Wealthy, a few years his junior (he was now thirty-five) and sexually predatory, Tulla chased him relentlessly, putting it about that they were to be married, never leaving him alone, following him from place to place and even from country to country. In his mind she epitomised the three feminine archetypes, the radiantly happy spring maiden, the sorrowing mother and the 'flame-haired temptress' (*The Dance of Life*). Her red hair was a major element in her attraction for Munch, and later in the disgust and desperation he felt on thinking about her. But he was certain in his mind that he must resist any sexual involvement with her in case his artistic impulse was compromised. Not unnaturally, she disagreed vehemently with this point of view, and the conflict became impossible for him to handle. His anxious mood is expressed in *The Red Vine* (*Virginia Creeper*) of 1898, in which the face in the foreground appears to be fleeing from some nameless horror in the house behind. The painting is suffused with red, a colour now reflecting not only Tulla's hair but the angst and confrontation associated with her. The affair continued on and off for several years, during which Munch grew closer and closer to a total breakdown. He found himself unable to work for a year or so, and retreated to the peace of a sanatorium for several months late in 1899. He moved on to Berlin, hoping for calm and stability; there, ironically, his reputation was growing, and his financial circumstances took a turn for the better, thanks to the patronage of Albert Kollmann. He returned to creative form only in 1901, when he was able to field over seventy paintings for an exhibition. Under Kollmann's aegis, Munch now joined the Berlin Secessionists who had made so pointed a move from traditional values in 1892. He enlarged and more or less completed the *Frieze of Life*, exhibiting the series at the Secession gallery in 1902. Critical acclaim was now his – he was seen as an artist of the future, in defiance of the earlier criticism that people had already seen everything he had to offer. By 1902 he was at the end of his tether with his stormy affair. Tulla, unable to give up in spite of his many attempts to escape her, lured him to her side by a subterfuge, threatening suicide if he did not come.

40. *Metabolism*, 1899,
Oil on canvas,
172.5 x 142 cm,
Munch Museum,
Oslo.

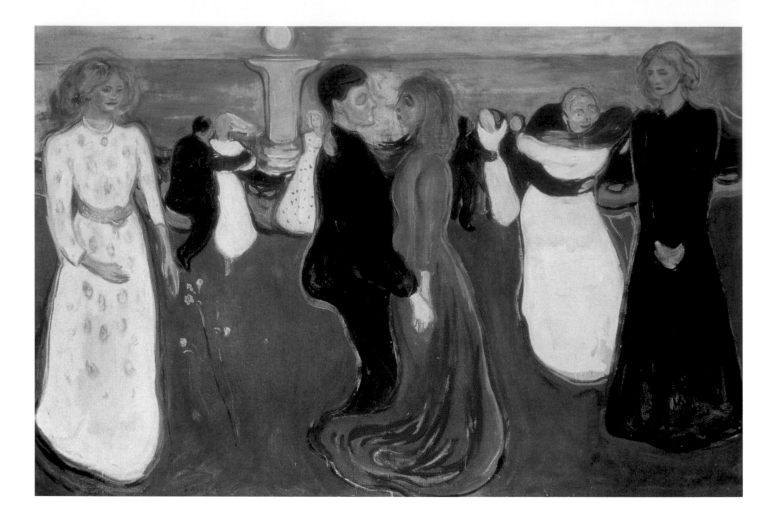

41. *The Dance of Life*,
1899-1900,
Oil on canvas,
125 x 191 cm,
Munch Museum, Oslo.

In the course of a disastrous sequence of events, a gun was fired; the shot badly, and permanently, damaged Munch's left hand. It is not clear who fired the gun, though it was an accident. While Munch was in hospital, Tulla fled. They were never to meet again. Munch sought refuge with a doctor friend in Lübeck, and there, for a time, found some kind of healing. He repaid the kindness with a series of paintings and engravings of the doctor's family and environs; one of the finest is the group portrait of *The Four Sons of Dr Linde* (1903). His last encounter with Tulla was depicted in *The Death of Marat* (1905-8), one of the many works he produced in this period in which she is seen as a murderess – either literally or as the slayer of his peace of mind. She did not let go, spreading malicious rumours about how he had lived off her wealth; she was somehow able to get his former friends, such as Krohg and Heiberg, to take her part, which made Paris very uncomfortable for him when he arrived there in 1903, only to hear, to his horror, that she was there, now married to a painter. Some good came out of this Paris visit. Munch made a new friend in the shape of Eva Mudocci, a

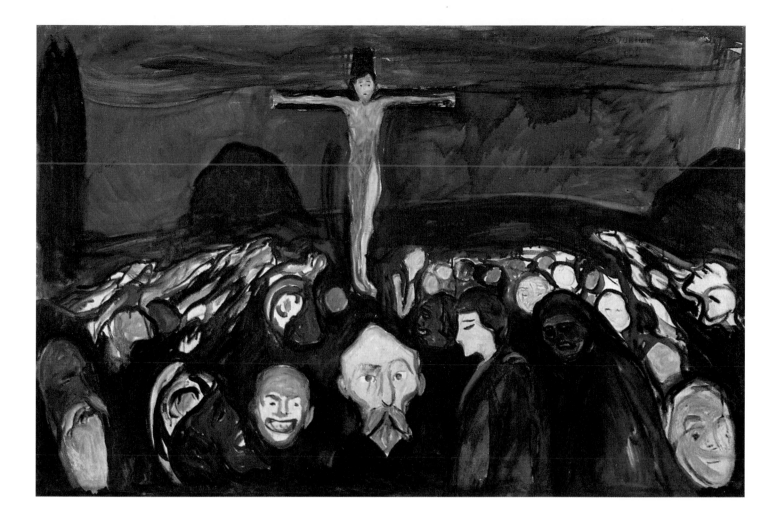

violinist whose beautiful eyes and luxuriant dark hair provided inspiration for a further series of lithographs (*The Lady with the Brooch*, 1903). Eva was unthreatening and tenderly affectionate, and this platonic friendship gave him some much-needed respite from turmoil. There now began a period of extensive travel, as he fled from the destructive effects of Tulla's passion. Feverish work resulted in numerous exhibitions throughout Europe and the United States – no fewer than sixteen in Berlin alone over the next few years. He was often very ill, in the grip of alcoholism, and suffering greatly from emotional stress. His *Self-Portrait with Brushes* of 1904 shows a man in control of himself: this is illusory, since by now he was subject to hallucinations and irrational outbursts of anger that put him in physical danger from others' reactions. Despite this fragile state, Munch the artist was now reaping the rewards of his years of work and striving. He found himself revered as the guiding light of the Expressionist group known as Die Brücke, who banded together in Dresden in 1905 and sought to follow where he led.

42. *Golgotha*, 1900,
 Oil on canvas,
 80 x 120 cm, Munch
 Museum, Olso.

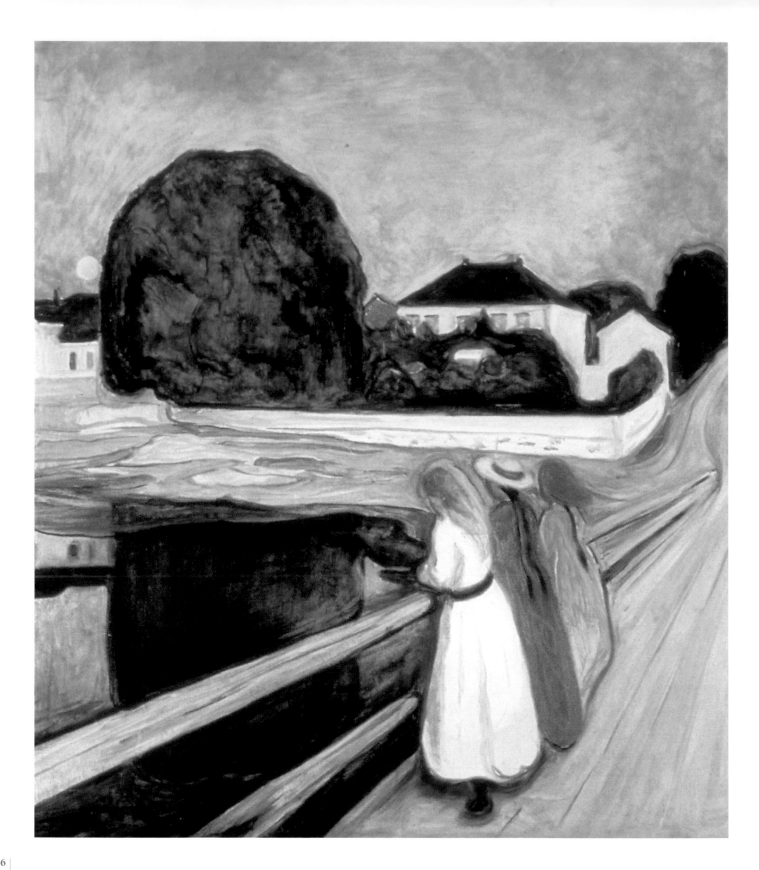

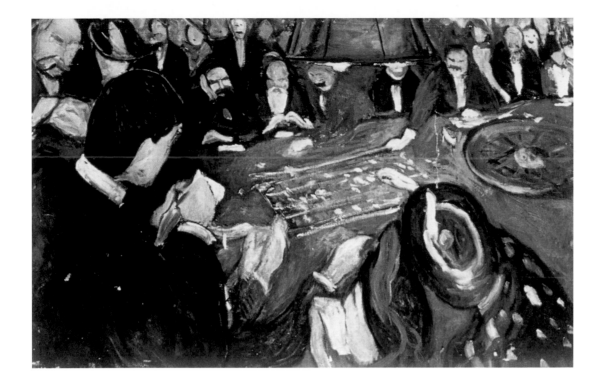

He was seen as encompassing the best of the German spirit in art, 'German' here having the wider sense of 'Nordic' or 'Germanic', and the influential strata of German society, embracing the Nietzschean concept of purity through struggle, took him to their hearts. A return to Åsgårdstrand did not allow him any time for recuperation, since the political situation was becoming volatile. The union of Norway and Sweden was dissolved in 1905, and war seemed likely. He went to Copenhagen, and then back to Germany where he took the cure at various spas and tried to control his drinking. In 1908, while setting up an exhibition in Copenhagen, total mental and physical exhaustion overwhelmed him, and a crisis, during which he heard voices and suffered persecution mania, caused him to be admitted to a psychiatric clinic, where he remained for some months. This was a turning-point. The extensive period of treatment and rehabilitation was remarkably successful, and the artist emerged with new vigour and an altogether more positive outlook. He also gave up drinking – indeed, he is said never to have drunk alcohol again. The doctor chiefly responsible for this happy outcome was immortalised in a fine portrait (*Dr Daniel Jacobsen*, 1909), his somewhat austere features enlivened by the warm reds and yellows of the background and the rich brown of his clothes. A poet friend of the doctor was also painted in the same year, in an equally fine portrayal (*Helge Rode*). A contributory factor in Munch's revival was surely his recognition by the state with his appointment as a Knight of the Royal Norwegian Order of St Olav.

43. *Girls on a Jetty*,
c. 1901,
Oil on canvas,
136 x 125.5 cm,
Munch Museum, Oslo.

44. *Roulette Table*,
1903, Oil on canvas,
Munch Museum, Oslo.

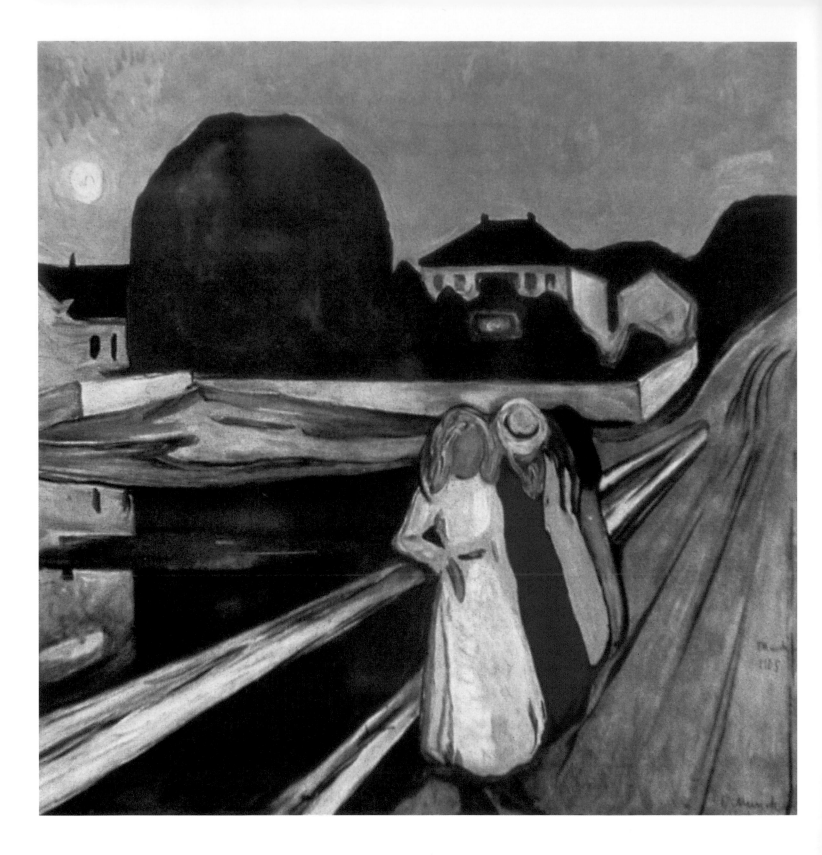

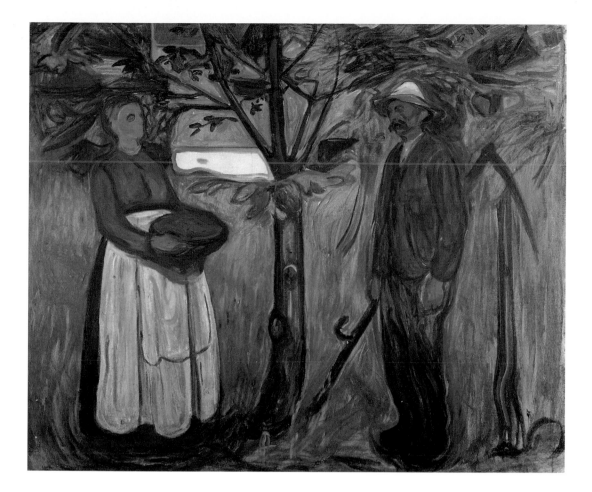

With his recovery came a determination to stop the endless, restless travelling and settle permanently in Norway. He bought a farm at Ramme on the Oslofjord, and also rented two other estates – Skrubben and Grunsrød. He visited these three in rotation, finding peace in the variety of landscape and closeness to the natural world. He led a simple life, saw few people outside those who worked on his estates, and drew fresh inspiration from the day-to-day life around him (*Workers in the Snow*, 1912). This period of breakdown and recovery was, hardly surprisingly, pivotal in Munch's art. Afterwards his work took on a sunnier, more relaxed tone. The anguish and sorrow of his earlier oeuvre did not vanish altogether – just as the artist himself did not become, overnight as it were, cured of his depression and the trauma of his youthful years – but the sadder aspects retreated and a new mood of optimism was now discernible. During his illness and recuperation, Munch managed to maintain his artistic activities, arranging exhibitions and painting the staff in the clinic. Indeed, continuing to work was therapy for him – before the easel he was in command of the people he depicted, rather than the reverse.

45. *Four Girls on the Bridge*, 1905, Oil on canvas, Wallraf-Richartz Museum, Cologne.

46. *Fertility II*, 1902, Oil on canvas, 128 x 152 cm, Munch Museum, Oslo.

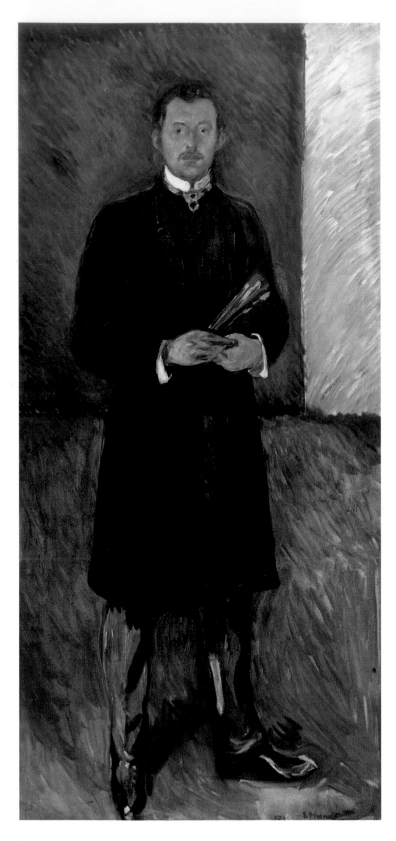
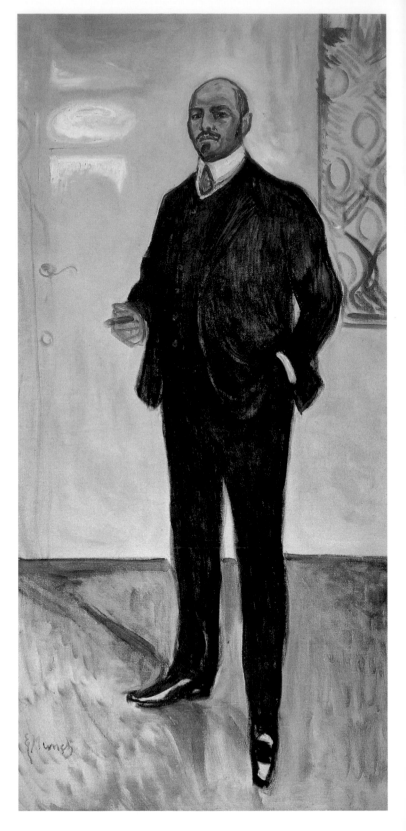

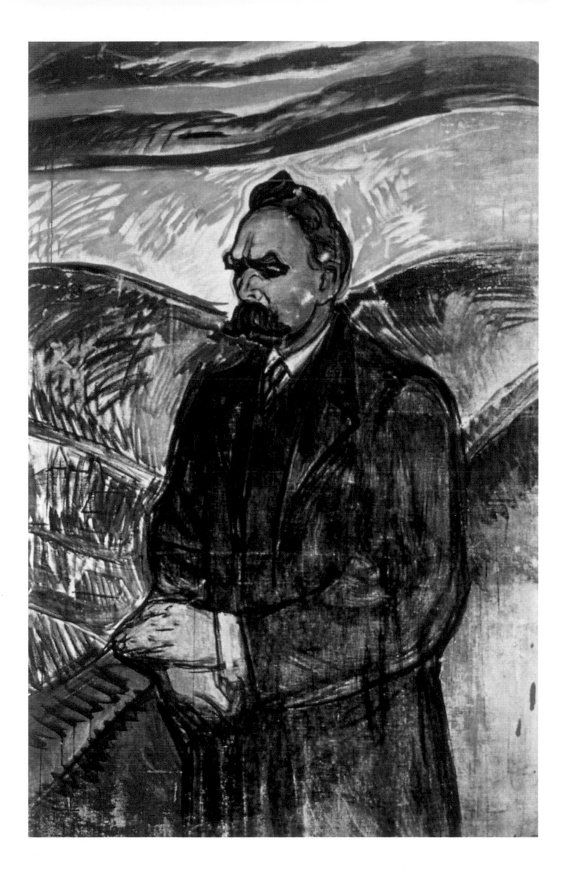

47. *Self-Portrait with Brushes,* 1904, Oil on canvas, 197 x 91.5 cm, Munch Museum, Oslo.

48. *Walter Rathenau,* 1907, Oil on canvas, 220 x 110 cm, Private Collection, Bergen.

49. *Nietzsche I,* 1906, Oil on canvas, 201 x 160 cm, Thielska Gallery, Stockholm.

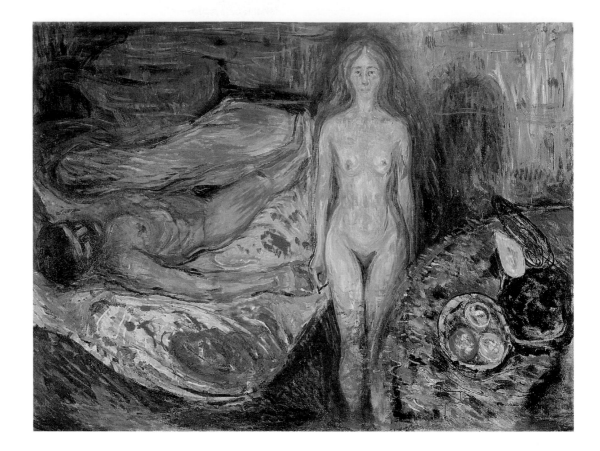

As recovery progressed, he made some momentous decisions. He now felt able to dismantle the *Frieze of Life* cycle, and sold various works from it. It was a way of putting the past behind him. His new optimism is given expression in the 1909 *Self-Portrait in Copenhagen*, which shows a revitalised figure, matured in the fires of suffering and now ready for a new phase in his life. One of the most important projects of this period was the commission to decorate the new Great Hall of Kristiania University. The University's centenary was celebrated in 1911, and leading Scandinavian artists were invited to enter the competition to produce murals for the new building. Munch, one of several painters who put in a successful application, started work in the spring of 1909, just at the point where he emerged from his illness revivified. Three enormous oil panels were designed, with smaller ones as decorative adjuncts. The left-hand one, entitled *History*, is a colossal work over 38 feet (11.5m) wide and nearly 15 feet (4.5m) high. It depicts a child standing before an elderly man, who is passing on his learning under the benevolent shade of an enormous oak. The branches of the massive tree stretch out over the pair as if imbuing its ancient knowledge to the boy – a kind of passage of wisdom from revered elder to callow youth.

50. *The Death of Marat*,
1905-1908,
Oil on canvas,
150 x 200 cm, Munch
Museum, Oslo.

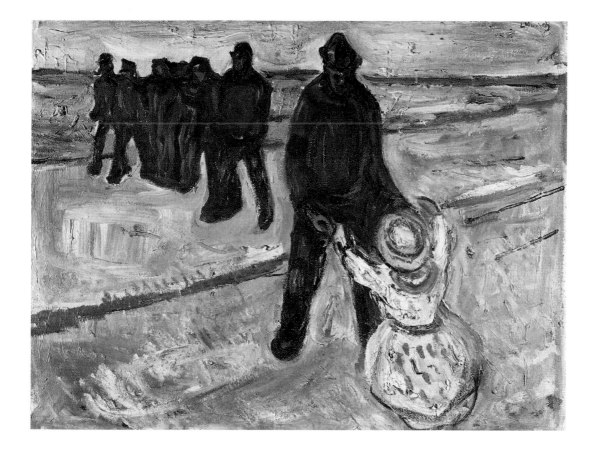

One commentator said the painting expressed 'the living process of transmission'. The central panel took as its theme the rising sun, the giver of all life. The longing for the sun was a theme that Munch returned to in his writings as well as his art. In a part of the world where the sun is more or less absent from daily life for almost half the year, its reappearance in spring and its life-giving radiance throughout the summer months were celebrated not just by painters. Naturism and sun-worship were becoming widely accepted in Northern Europe, as was a romantic view of pre-industrial life on the land, in tune with nature. In this huge oil painting the sun rises out of the sea, throwing its light over the fjords, hills and valleys all around. The rays are painted in a geometric fashion, the concentric circles made up of rectangles, with streaks and dashes of colour from all shades of the spectrum. A few minuscule figures look up in wonder at the celestial show. The third main panel is entitled *Alma Mater*, and celebrates the benign female principle. The placid earth-mother nursing her baby is surrounded by other young children in a fresh, summery landscape. Again the sea provides an important element of the composition.

51. *The Worker and the little girl*, 1908, Oil on canvas, 76 x 90 cm, Munch Museum, Oslo.

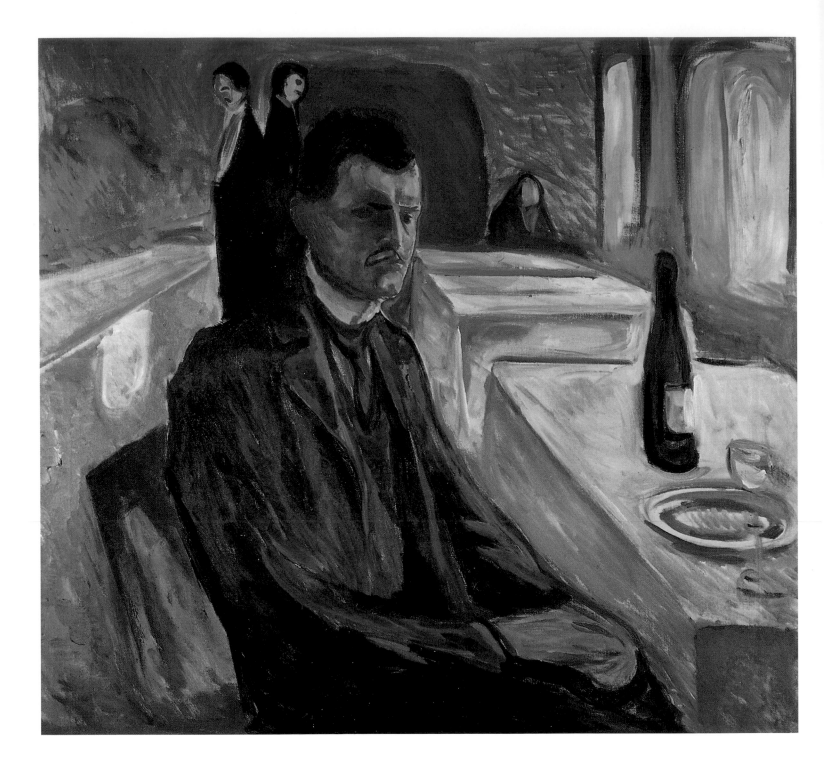

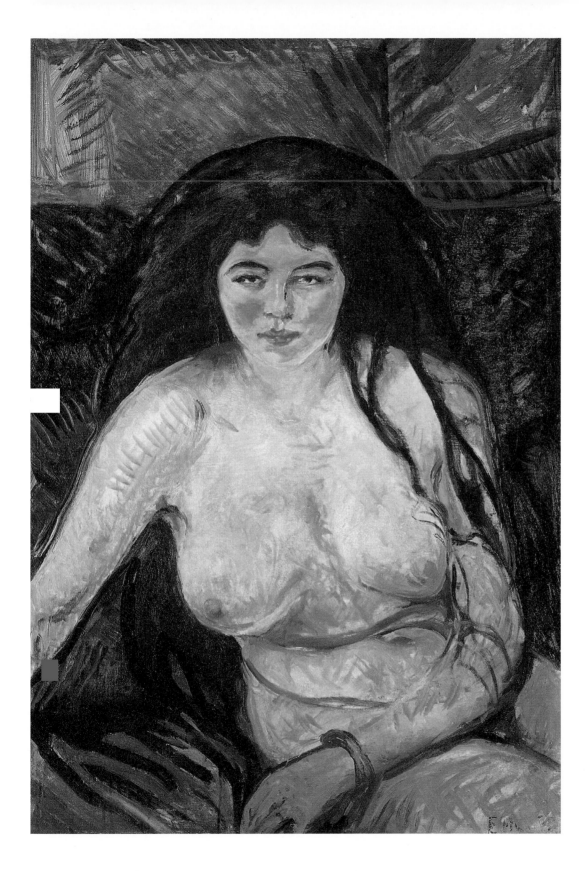

52. *Self Portrait at
 Weimar*, 1906,
 Oil on canvas,
 110.5 x 120.5 cm,
 Munch Museum,
 Oslo.

53. *The Beast*, 1902,
 Oil on canvas,
 94.5 x 63.5 cm,
 Sprengel Museum,
 Hanover.

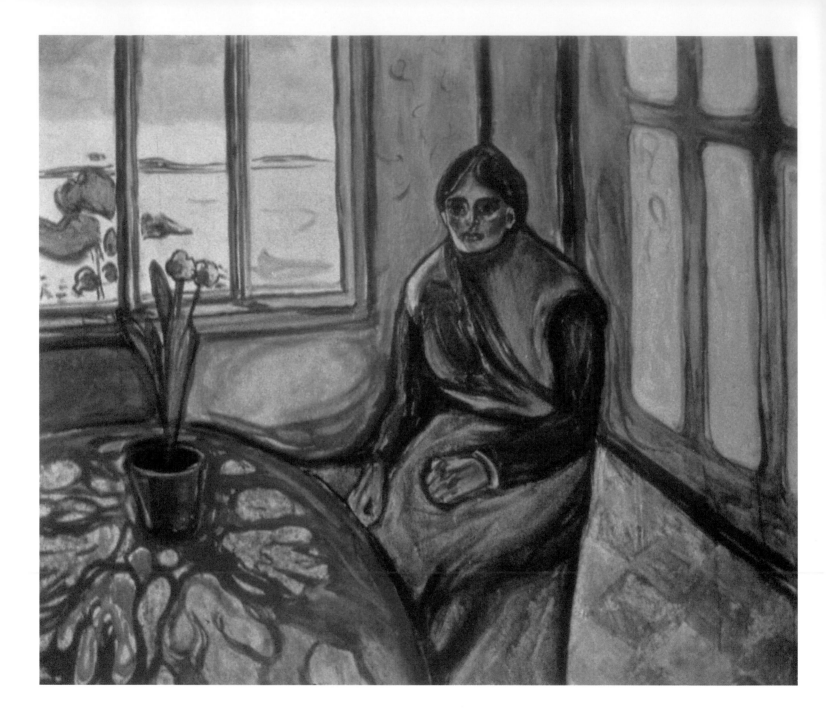

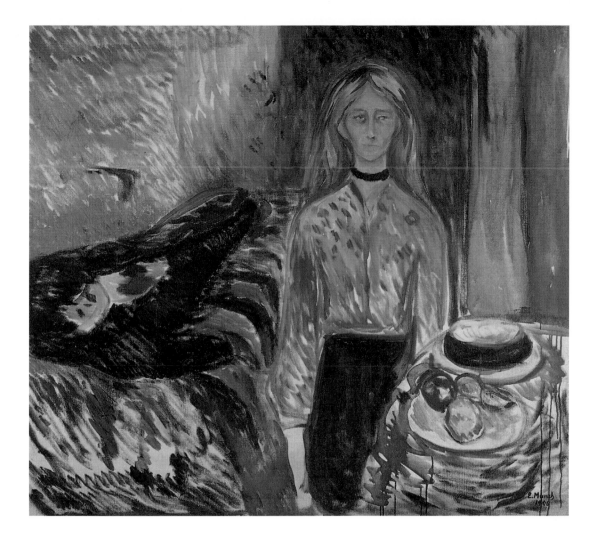

The painting contrasts the ripe fruitfulness of the young mother with the interaction of extreme age and youth in *History*. All three panels, with their smaller framing subjects, are intended to express the whole of human life in a spirit that is both particularly Norwegian and also universally recognised. We have already noticed how Munch could be termed the forerunner or prime mover of Expressionism through his apotheosis by the Brücke group of artists. The next move in this process was the invitation to exhibit in 1912 with the Sonderbund artistic group, based in Düsseldorf. Their work was already being termed Expressionism, a way of describing the subjectivism of the artist and the attempt to elicit an intuitive response in the viewer by means of intense colour, monumental forms and simple, strong lines. Munch was in interesting company: fellow artists held to be inspirational for the movement were Van Gogh (above all), James Ensor and Ferdinand Hodler. A major exhibition was mounted in Cologne, with artists from all over Europe participating.

54. *Melancholy (Laura)*, 1899, Oil on canvas, 134.5 x 160 cm, Munch Museum, Oslo.

55. *The Murderer*, 1906, Oil on canvas, 110 x 120 cm, Munch Museum, Oslo.

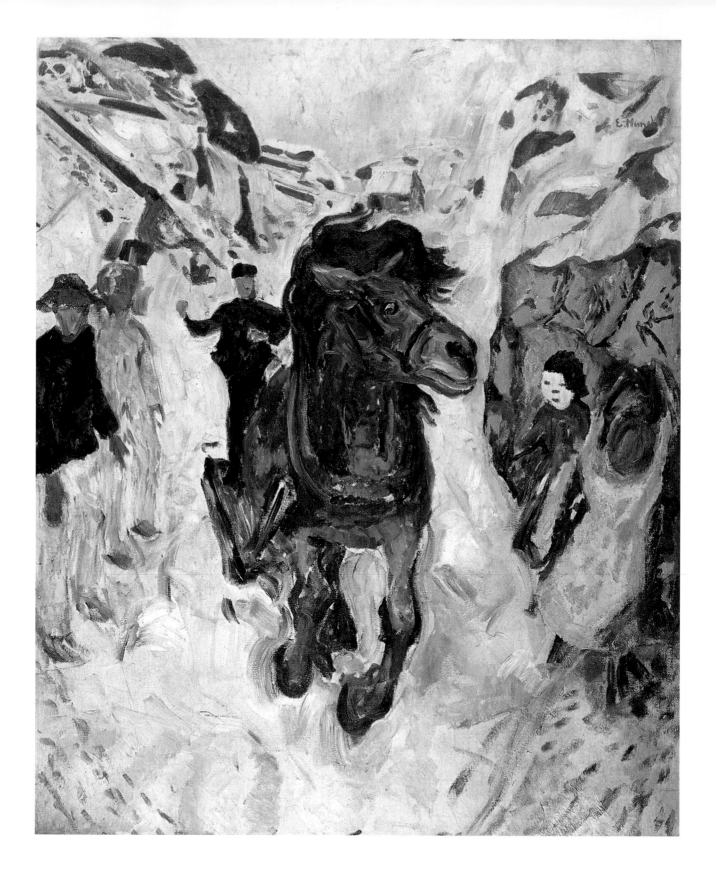

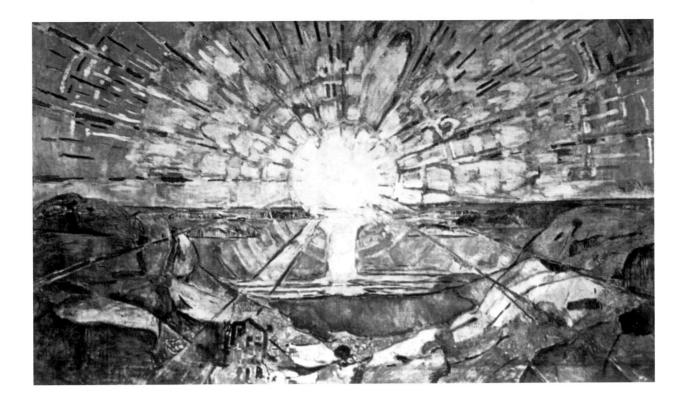

When Munch saw it he wrote, 'Here is collected the wildest of what is being painted in Europe. I am actually classical and pale in contrast. The cathedral of Cologne is trembling in its foundations.'[6] The Germanic awakening that Munch had helped to foster was a primary element of the Expressionist movement. The heirs of the first phase, Emil Nolde, Ernst Ludwig Kirchner, Oskar Kokoschka and to some extent Egon Schiele, turning their backs on the creative ferment of Paris, focused on Vienna, where Freud's psychoanalytical theories chimed perfectly with their subjective introspection. The natural progression of the movement led to a kind of violent realism which eventually found itself in confrontation with Nazi ideals of artistic worth. Expressionism developed in many forms and with many subdivisions, in Belgium and the Netherlands, the USA, Latin America, France, Spain and Italy. Picasso's *Guernica* is the ultimate vision of Expressionist violence. After World War II the American exponents of Abstract Expressionism included Arshile Gorky, Jackson Pollock, Willem de Kooning, Mark Rothko, Franz Kline, Clyfford Still and Robert Motherwell. The line connecting Munch to the great American painters of the 1950s, therefore, while not exactly a straight one, is a discernible thread that associates these iconic masters with the tortured Nordic genius: what links them is 'the will to express the inner world of man, composed of dramatic impulses, violence, and questions without answers'.[7] The Expressionists, unhappy at their evaluation by the Berlin public and critics, seceded yet again in 1913.

56. *The Galloping horse*,
 1910-1912,
 Oil on canvas,
 148 x 119.5 cm,
 Munch Museum,
 Oslo.

57. *The Sun*, 1909-1911,
 Oil on canvas,
 490 x 25.4 x 66.04 cm,
 Mural in the Festival
 Hall of Oslo
 University, Oslo.

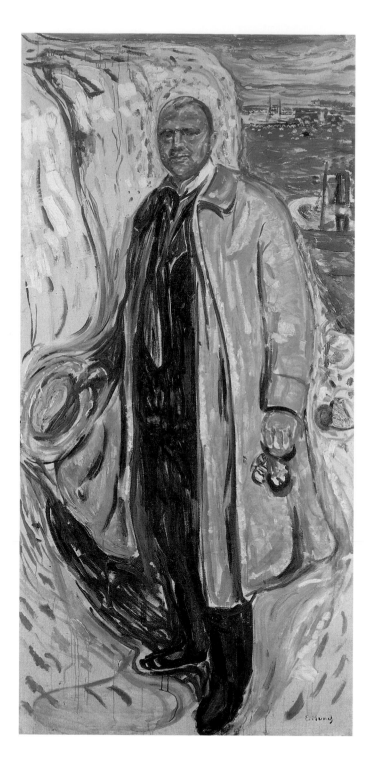
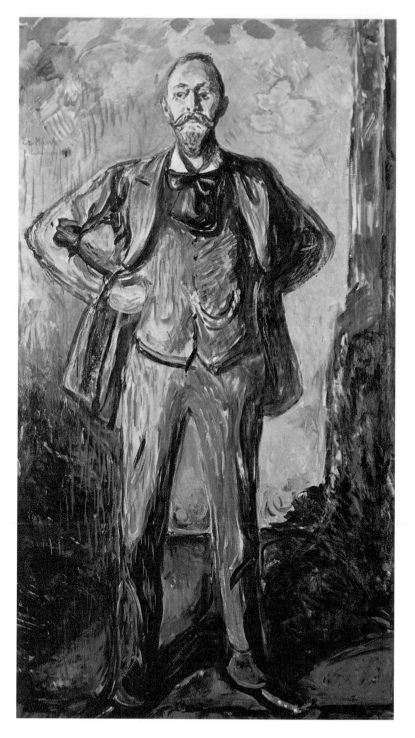

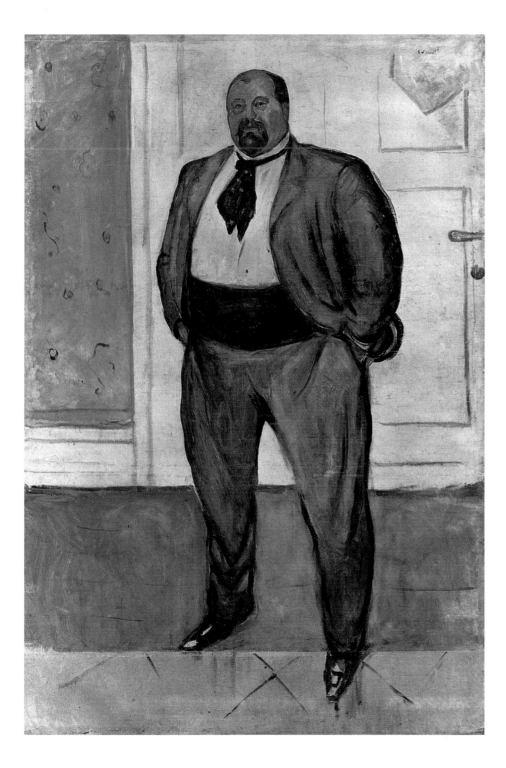

58. *Christian Gierloff*,
1910, Oil on canvas,
205 x 98 cm, Art
Museum, Göteborg.

59. *Dr. Daniel Jacobsen*,
1909, Oil on canvas,
110.5 x 120.5 cm,
Munch Museum,
Oslo.

60. *Christen Sandberg*,
1909, Oil on canvas,
215 x 147 cm, Munch
Museum, Oslo.

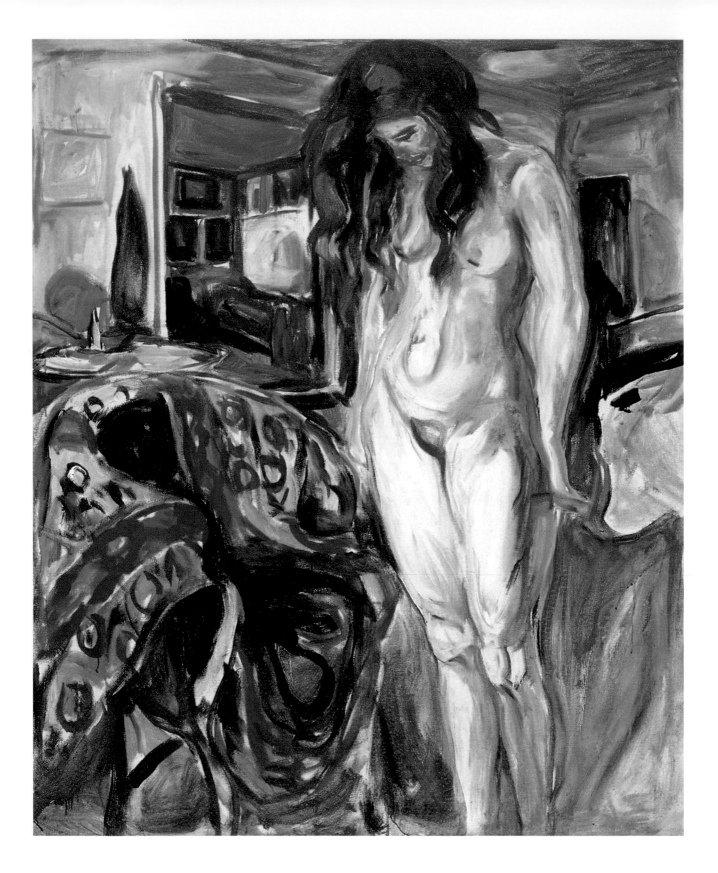

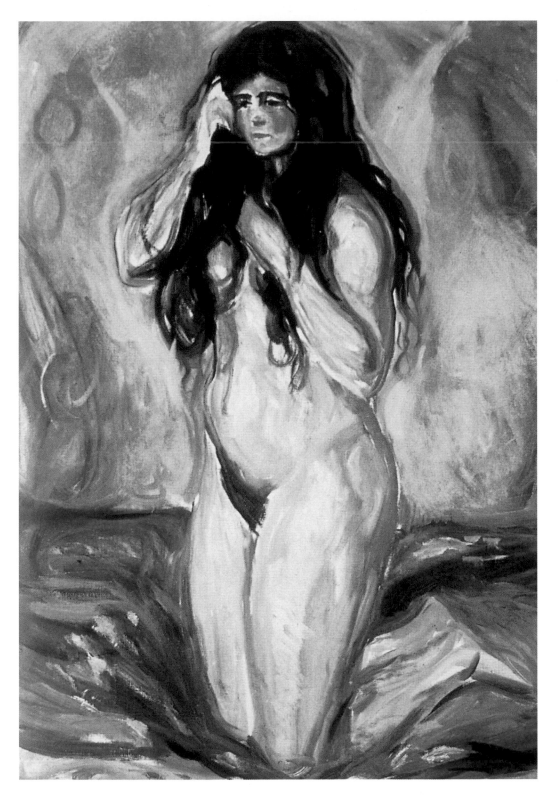

61. *Model by the wicker
 chair,* 1919-1921,
 Oil on canvas,
 122.5 x 100 cm,
 Munch Museum,
 Oslo.

62. *Kneeling Female
 Nude (Anna),* 1919,
 Oil on canvas, Sarah
 Campbell Blaffer
 Foundation, Houston.

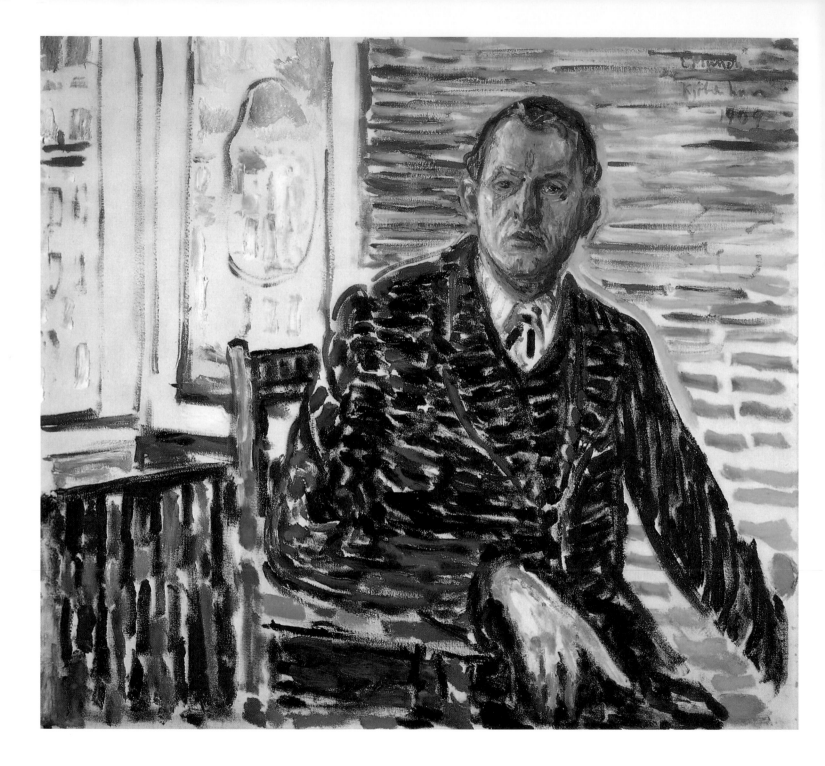

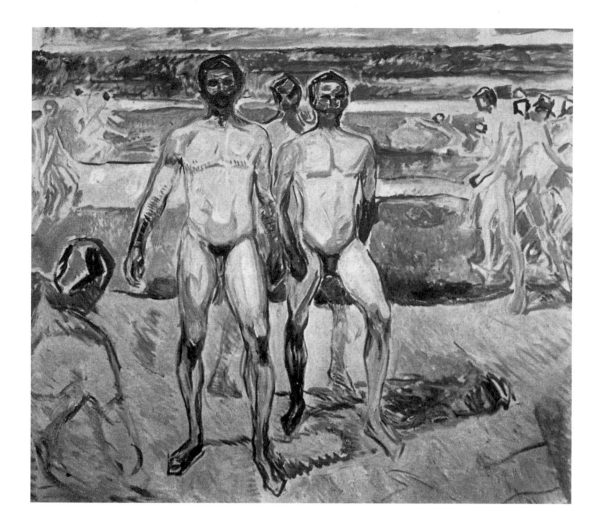

Munch was asked to exhibit with them to mark his fiftieth birthday: the show was a triumph. Even his Norwegian critics conceded defeat, and his work was enthusiastically bought, reviewed and celebrated in books and newspapers. The Great War was difficult for Munch to come to terms with. His natural inclination was to side with Germany, his spiritual home and quasi-adoptive country. But he could not maintain this support in the face of the millions of needless deaths reported, and he retreated into isolation. His work became somewhat repetitive as he sought to make sense of what he had produced so far. At Ekely, the estate which he bought in 1916, he created studios to display the latest versions of his *Frieze*. He was unable to stop this endless reworking, which did not always improve on the original. One new departure was his concentration on painting nudes. These days all sexual interest in women seemed to be at an end, and his eye regarded them dispassionately, even slightly cruelly.

63. *Self Portrait in Dr. Jacobson's clinic*, 1909, Oil on canvas, 100 x 110 cm, Private Collection, Bergen.

64. *Bathing Men*, 1907-1908, Oil on canvas, 206 x 277.5 cm, Ateneum Art Museum, Helsinki.

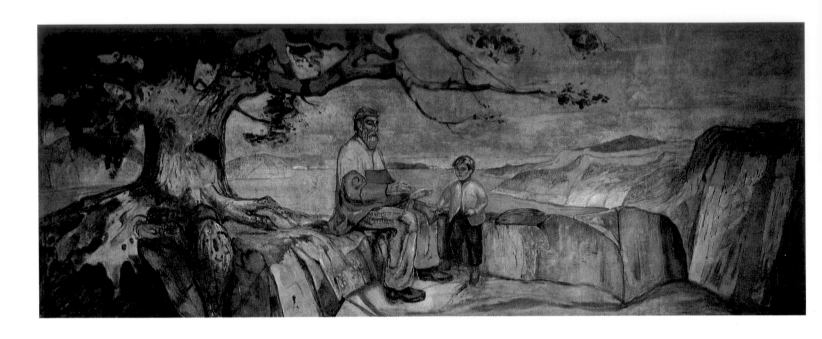

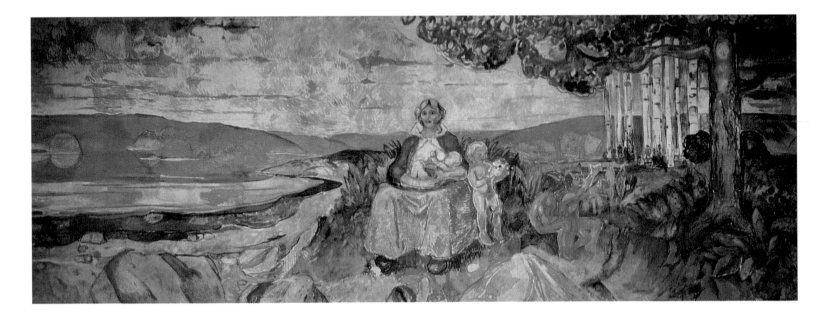

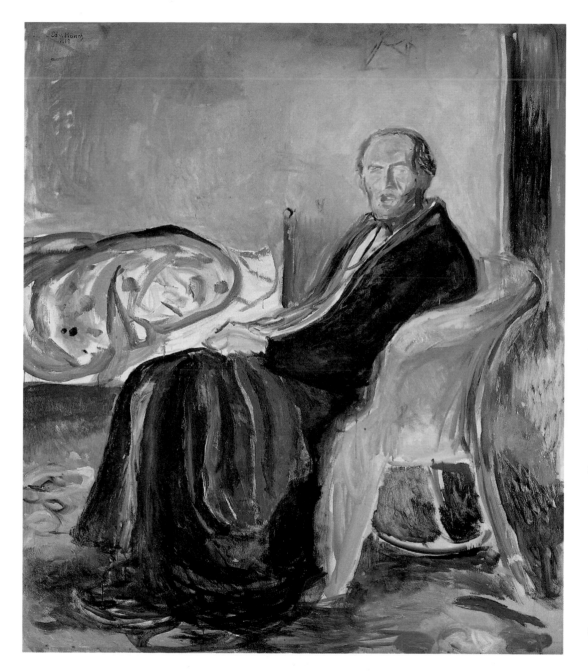

65. *History,* 1911-1916,
 Oil on canvas,
 4.5 x 11.6 m, Mural
 in the Festival Hall of
 Oslo University, Oslo.

66. *Alma Mater*,
 1911-1916,
 Oil on canvas,
 4.5 x 11.6 m,
 Mural in the
 Festival Hall of Oslo
 University, Oslo.

67. *Self-portrait after the*
 flu, 1919, Oil on
 canvas, 150.5 x 131 cm,
 Munch Museum, Oslo.

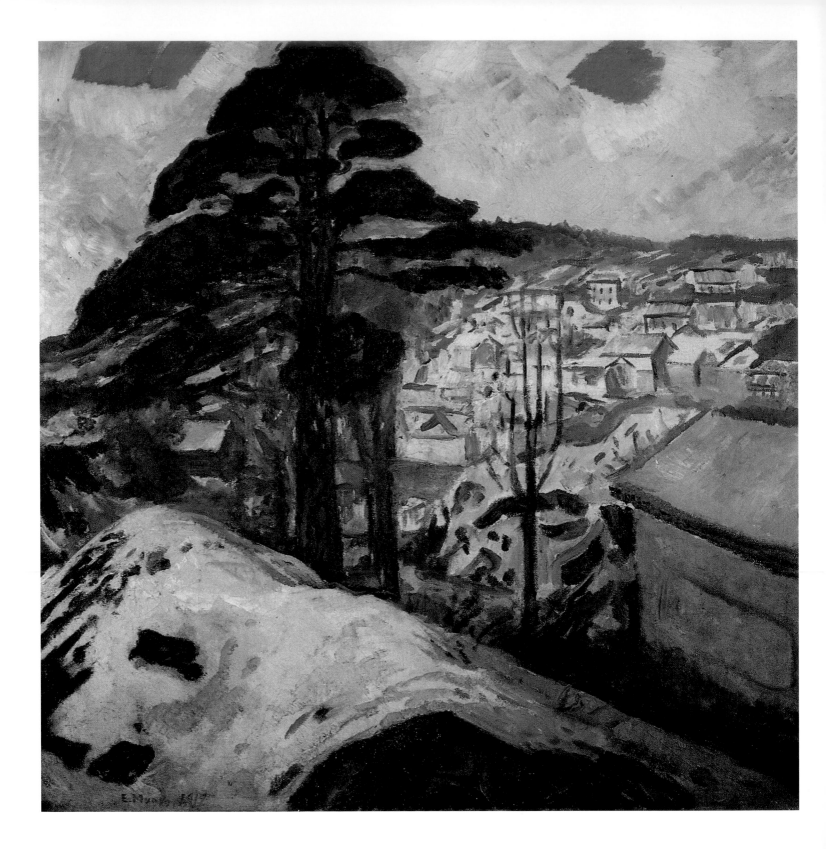

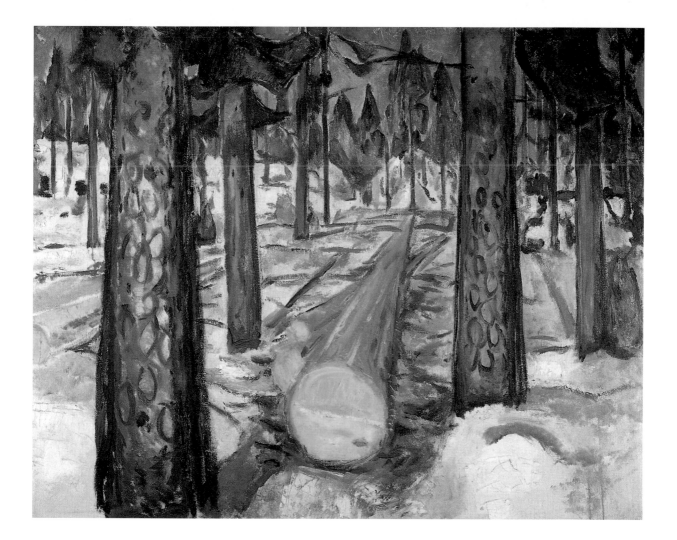

He embraced the nobility of the worker in his somewhat naive celebrations of cabbage-pickers and snow-shovellers (*Workers Returning Home*, 1915), and hoped to foster a social climate in which the rule of the people would hold sway. The commission to decorate the walls of the canteen at the Freia Chocolate Factory in Oslo (1921–2) was a direct result of this philosophy. His last years were ones of failing health and also failure to come to terms with the tremendous social and political changes wrought by World War I. The celebration of his seventieth birthday in 1933 was, however, a gratifying recognition of all that he had achieved; but soon afterwards the rise of Nazism in Germany and the categorising of his work as 'Degenerate Art' was a slap in the face from his spiritual home. The outbreak of World War II upset and depressed him. The final act came when an explosion, the first of the war in Norway, broke the windows of his house at Ekely in late 1943 and he died of the resulting chill on 23 January 1944. He was just eighty years old; he was tired and had no more to give.

68. *Winter in Kragorö*, 1912, Oil on canvas, 131 x 131 cm, Kunsthaus Zurich, Zurich.

69. *The Yellow log*, 1911-1912, Oil on canvas, 131 x 160 cm, Munch Museum, Oslo.

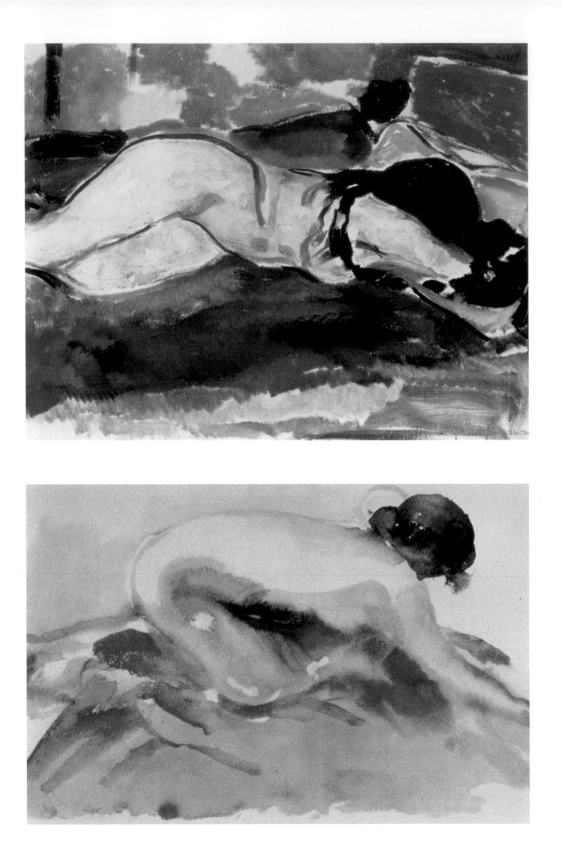

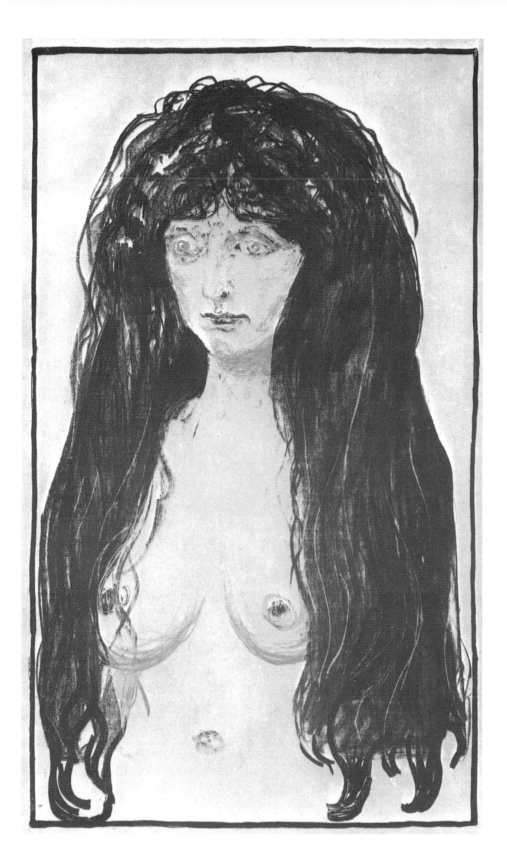

70. *Reclining Nude*,
 1912-1913,
 Oil on canvas,
 Kunsthalle, Hamburg.

71. *Crouching Woman*,
 c. 1920, Watercolour,
 Private Collection.

72. *The Sin (Nude)*, 1912,
 Coloured Lithography,
 49.5 x 39.9 cm,
 San Diego Museum
 of Art, San Diego.

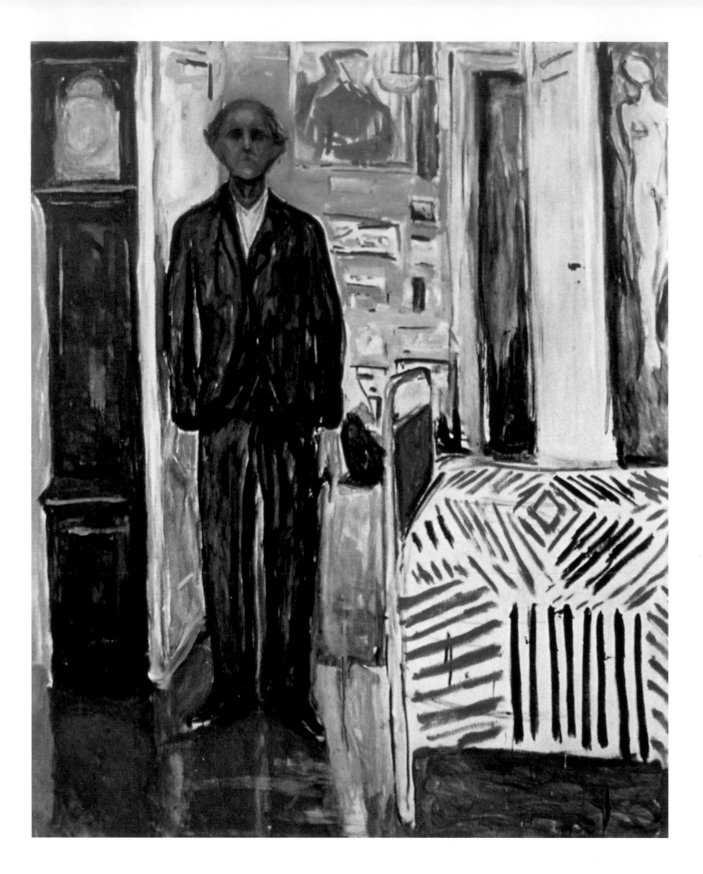

BIOGRAPHY

1863	12 December: born in Løten, Norway, the second child of Laura (née Bjølstad) and Christian Munch. Father is a doctor. There are to be three further children: Andreas, Laura and Inger.
1864	The family moves to Kristiania (Oslo).
1868	Mother dies of tuberculosis, aged thirty.
1877	Elder sister Sophie dies of tuberculosis aged sixteen.
1879	Attends the Technical College in Kristiania to study engineering. Produces his first sketches in May.
1880	Takes up painting in earnest; studies in Kristiania under Hans Olaf Heyerdahl and Christian Krohg.
1881	Studies at the Royal School of Art and Design under Julius Middelthun.
1882	Rents studio in Storting Square with six other artists. Annual Autumn Exhibition founded, with state aid, by Werenskiold, Krohg and Thaulow.
1883	First exhibition as part of a group; *Head of a Red-Haired Woman*.
1884	*A Servant Girl* bought by Thaulow, first real sale. *Karen Bjølstad in a Rocking-Chair*. Thaulow gives him money to enable him to visit Antwerp and study in Paris; visit postponed for a year because of illness. Starts relationship with Emilie Thaulow.
1885	First visit to Paris. Returns with an Impressionist style and paints as 'the first and only Impressionist of Norway' (Krohg). Denies the existence of God. *The Sick Child* begun.
1886	Member of avant-garde group 'Kristiania's Bohemia', founded by the writer Hans Jaeger and concerned with innovative moral, political and social thinking.
1889	First one-man show, with 110 works. Gains a state scholarship and returns to Paris in October. Studies with Léon Bonnat. Drawn to Van Gogh and Gauguin, Neo-Impressionists, Symbolists. Begins to put together *The Frieze of Life* as a series, partly from works already completed. Summer at Åsgårdstrand, by the sea. Sees his father for the last time, who dies in November.
1890	Returns to Norway via Antwerp. Ten paintings at Autumn Exhibition, including *Spring Day on Karl Johan Street*. Goes back to France with a renewed scholarship; falls ill.
1891	Stays in Nice to recover from illness. Returns to Kristiania in May. Work takes on a dark expressiveness. *The Kiss*.

73. *Self Portrait between bed and clock*, 1940-1942, Oil on canvas, 149.5 x 120.5 cm, Munch Museum, Oslo.

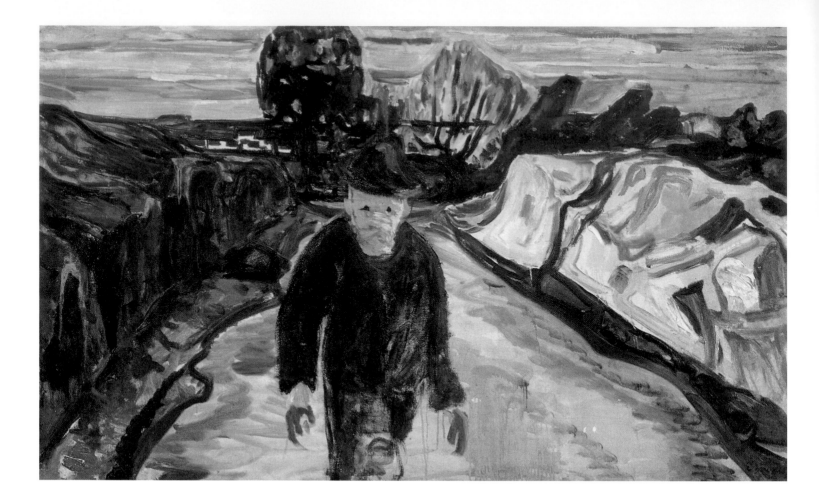

1892 Returns to Nice for the winter. Exhibits in Kristiania and is praised by Krohg. Invited to exhibit at the Association of Berlin Artists; his section closed by the organisers as scandalous. *Spring Evening on Karl Johan Street*. Lives on and off in Germany for sixteen years.

1893 Returns to Norway reinvigorated. *Madonna*; *The Vampire*; *The Scream*. Exhibits with the Berlin Secession. *Death in the Sick-Room*.

1894 Starts to make engravings and etchings. New style in monochrome is sharper and more precise than the painting style. *Separation*. Works at furious pace.

74. *The Killer*, 1910, 1895 *Jealousy*. Returns to Norway.

Oil on canvas, 1896 Back in Paris; paints Mallarmé; makes the acquaintance of the Nabis; exhibits his

94.5 x 154 cm, *Frieze of Life* paintings at the Salon des Indépendants, and at Samuel Bing's Art

Munch Museum, Nouveau Gallery. Designs sets for Ibsen's *Peer Gynt*. Mostly produces colour

Oslo. lithographs; *Revue Blanche* publishes lithograph of *The Scream*. Brother Andreas dies.

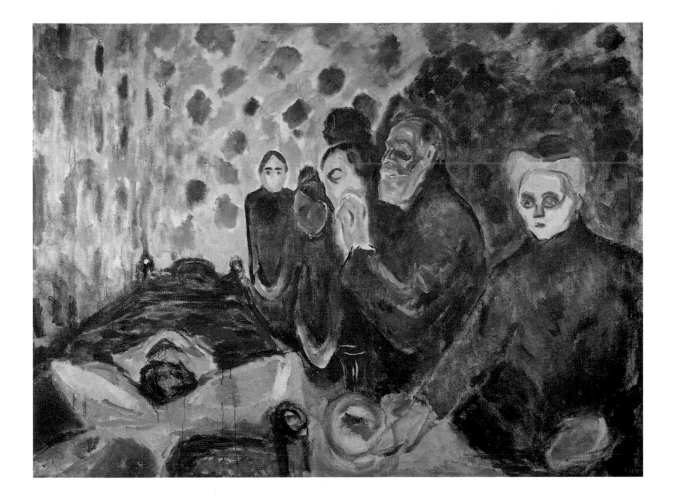

1898	Meets Tulla Larsen. *The Red Vine (Virginia Creeper)*. *Man and Woman*.	
1899	Enters a sanatorium in Norway. The National Gallery in Kristiania buys two pictures. *Portrait of Aase and Harald Nørregård*.	
1900	*The Dance of Life*.	
1901	*The Frenchman*. Exhibits seventy-two paintings in Kristiania.	
1902	Exhibits twenty-eight paintings, including the *Frieze of Life* series, at the Berlin Secession gallery, along with Hodler and Kandinsky. Meets Albert Kollmann. Disastrous end of relationship with Tulla Larsen.	
1903	Meets Eva Mudocci; stays in Lübeck with the Linde family. *The Four Sons of Dr Linde*.	75. *By the Death bed (Fever)*, c. 1915, Oil on canvas, 187 x 234 cm, Munch Museum, Oslo.
1904	Visits several German cities including Weimar. *Self-Portrait with Brushes*.	
1905	Retrospective exhibition in Prague includes *Frieze of Life*. Dissolution of union of Norway and Sweden: political crisis.	

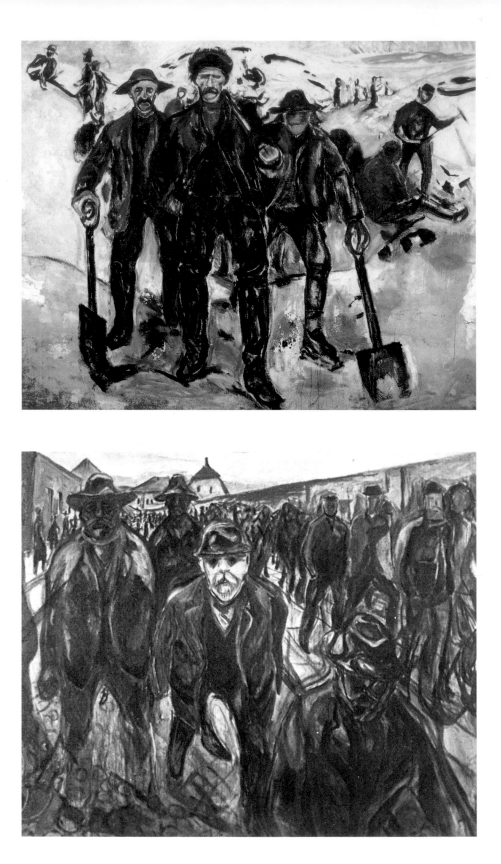

76. *Workers in the Snow*,
 1913, Oil on canvas,
 163 x 200 cm, Munch
 Museum, Oslo.

77. *Workers Returning
 Home,* 1915,
 Oil on canvas,
 201 x 227 cm, Munch
 Museum, Oslo.

1906 *Allegorical Portrait of Friedrich Nietzsche.*

1907 *Portrait of Walter Rathenau.*

1908 Exhibition in Copenhagen. Breakdown; enters a clinic. *Mason and Mechanic* – first of his portraits of artesans. Jens Thiis, Director, buys five paintings for the National Gallery in Kristiania. Ten further pictures presented by Olof Schou in this and the following year. Becomes Knight of the Royal Norwegian Order of St Olav.

1909 Recovers and returns to Norway. Exhibition of 100 paintings and 200 graphic works at Blomqvist Gallery, Kristiania. Portraits of *Jens Thiis, Dr Daniel Jacobsen, Helge Rode. Self-Portrait in Copenhagen.*

1910 Buys farm and estate at Ramme; rents another estate at Grimsrød.

1912 *Workers in the Snow*; *Galloping Horse.* Sonderbund exhibition, Cologne: over 570 works by 160 artists.

1909-12 Murals for Great Hall, Oslo University.

1913 Expressionist exhibition, Berlin; graphic works at Armory Show, New York.

1915 *Workers Returning Home.*

1916 Buys estate at Ekely, in Skøyen, where he lives until his death; builds studio room for exhibiting *Frieze of Life.* Paints country subjects.

1919 Exhibition of graphic works in New York. *Self-Portrait Recovering from Flu.*

1921-22 Murals for canteen of Freia Chocolate Factory, Kristiania.

1922 One-man show in Zürich, 'the best I ever had': 73 paintings, 389 graphic works.

1923 Becomes a member of the German Academy.

1925 Honourable member of the Bavarian Academy. Kristiania becomes Oslo.

1926 International Exhibition, Dresden. Kunsthalle, Mannheim. Death of sister Laura.

1927 Kronprinzenpalais, Berlin: 223 paintings exhibited.

1928 International Exhibition, San Francisco. Exhibits for the first time in London, at the Royal Society.

1931 Invited to exhibit in Edinburgh by the Society of Scottish Artists.
 Death of his aunt Karen.

1932 Exhibition in Glasgow organised by the National Gallery of Scotland.

1933 Monographs by Jens Thiis and Pola Gauguin published. Receives French Légion d'Honneur; Grand Cross of Royal Norwegian Order of St Olav.

1935 Exhibition of paintings in New York.

1937 Visits Gothenburg, his last trip abroad.

1940 *Between the Clock and the Bed*, self-portrait. Norway occupied by the Nazis.

1944 23 January: dies at Ekely. Leaves all his works to the city of Oslo (1,000 paintings, 450 watercolours, over 15,000 prints).

1946 Munch Bequest Exhibition, Oslo.

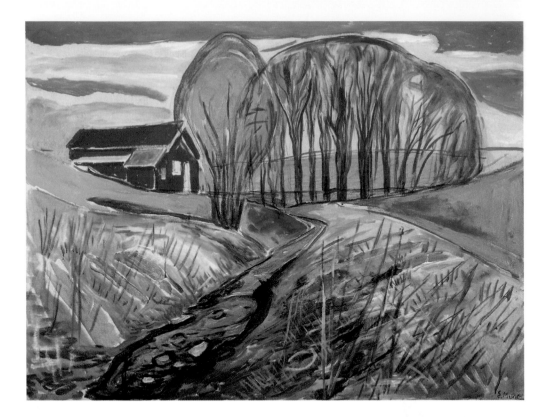

78. *Springtime Landscape with Red House*, 1935, Oil on canvas, 100 x 130 cm, Munch Museum, Oslo.

79. *Red farm and fir trees*, c. 1927, Oil on canvas, 100 x 130 cm, Munch Museum, Oslo.

80. *Winter Landscape near Krageroe*, 1925-1930, Oil on canvas, 91 x 91 cm, Kunsthaus, Zurich.

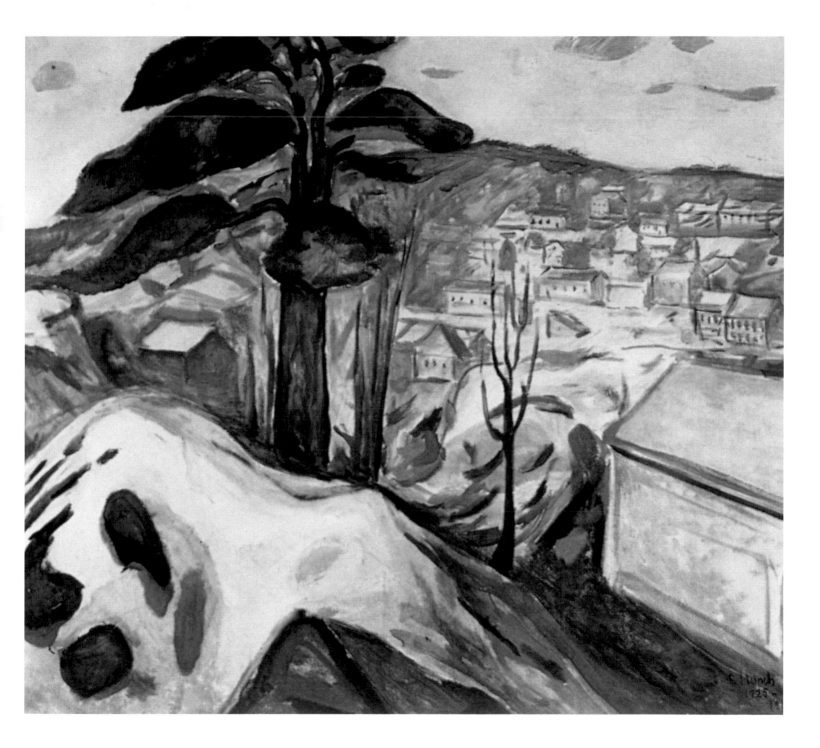

LIST OF ILLUSTRATIONS

NOTES

1. Quoted in J.P. Hodin, *Edvard Munch*, World of Art series, London 1972, p. 22.

2. Sketchbook T127, Munch Museum archives.

3. Reinhold Heller, *Munch: His Life and Work*, London 1984, p. 66.

4. Diary, St-Cloud, 1889, quoted in Hodin, *op. cit.*, p. 50.

5. Ms T2760, p. 44, Munch Museum archives, quoted in Heller, *op. cit.*, p. 76.

6. Letter to Jappe Nilssen, c. 23 May 1912. Quoted in Heller, *op. cit.*, p. 211.

7. Jean Leymarie, 'Expressionism', *Pall Mall Encyclopaedia of Art*, London and New York 1971.